1989

Broadcast Programming and Promotions Worktext

Broadcast Programming and Promotions Worktext

Marilyn J. Matelski, Ph.D.
Boston College

Focal Press
Boston London

Focal Press is an imprint of Butterworth Publishers.

ISBN 0-240-80025-7
Library of Congress Catalog Card Number: 88-83541

Butterworth Publishers
80 Montvale Avenue
Stoneham, MA 02180

10 9 8 7 6 5 4 3 2 1

Printed in the United States of America

To Janet, Lisa, Amy, and Tippy

Contents

Preface

Since the early 1920s, broadcasting has been an integral part of most Americans' lives. Research shows that much of our waking leisure time is devoted to some form of media news, information, or entertainment. As such, it should come as no surprise that radio/television programming has developed into a significant area of study over the past several years. It is no longer enough merely to understand the growing technology; we also must understand the strategies of the programming and promotion within that technology.

To achieve this objective, two very important elements are necessary: learning the *vocabulary* of the broadcast programming business and exploring the bases behind the decisions made by today's radio and television programming/promotion executives. Several excellent books currently fulfill the former goal quite adequately. The purpose of *Broadcast Programming and Promotions Worktext* is to concentrate on the latter aspect--media *strategy.* Thus, the basic material provided in this book is not intended to be conclusive, either historically or ideologically. Rather, it should be seen as a means to refresh the reader's memory and to establish a learning context for the case studies that follow.

Each case in this workbook presents a fictional problem (based on an actual situation) that contains the following essential elements: 1) a set of audience demographics, 2) the contextual background behind the problem, 3) relevant programming terms and concepts that might prove helpful, and 4) some suggested aids/diagrams to help you formulate your proposed strategy. Remember that, in most cases, no clear-cut, singularly correct answer exists to solve the case study problem. It is up to you to choose a solution, find relevant data to support your decision, and present a strong argument for your strategic point of view. So doing, you will find yourself in much the same position as most programmers in all levels of radio and television.

Acknowledgments

Recently, a colleague of mine joked that the first page most readers turn to is the Acknowledgments page. If their friends are mentioned, they read on; if not, the book often is assigned to the dustiest portion of the bookcase. Thus, at the risk of relegating this text to an obscure place, I wish to recognize those people who have been invaluable in its completion.

To my parents, Carolyn and Harry Matelski, who have gathered enough articles and proofread enough pages to be considered consummate writers themselves. To my programming classes at Boston College, who have helped me to write. . . and rewrite. . . many of the case studies found in this book. To Marc McNamara and Jim Dunford, who have encouraged me to "keep plugging" by offering helpful suggestions and research materials. To Dr. Nancy Street, who has continued to be a great friend and colleague since our graduate school days. To Al Cohen-- the best promoter for whom anyone could ever hope. To Karen Speerstra, Phil Sutherland, and the staff at Focal Press, who truly have made this a most pleasurable experience. And to the friends who have patiently left messages on my answering machine while I was busily wordprocessing at Boston College's Faculty Computer Center all those nights--thank you all!

Chapter 1. Introduction

Programming and promotion are among the most important considerations found in radio and television today. Such was not always the case, however. The earliest concentrated efforts in the broadcast media centered around the regulations of government, the race for technical superiority, and the business of station ownership. The following narrative provides a brief evolutionary perspective on radio and TV programming that highlights these aspects. For a more detailed history, please consult the sources found in Chapter 2.

GOVERNMENT PHILOSOPHY

Historical Background

In the early days of radio, a nation's broadcast policy could be found somewhere on a continuum between "competitive" and "authoritarian", with "benevolent" programmers in between the two extremes.

Figure 1.1. The range of government broadcasting philosophies.

Placed at the far end of the scale and unlike most of the world, the United States entered the era of broadcasting by adopting a **competitive** or (permissive) governmental policy toward its

media. It thus allowed for the private ownership of stations (rather than state-held posts); it also tried to minimize broadcast regulation as much as possible. Thus, for the most part, the Federal Radio Commission [later called the Federal Communications Commission (FCC)] emphasized technical restrictions to prevent frequency noise, misuse of distress signals, station overlap, etc. The FCC later included specific programming requirements that would maintain public interest standards, such as equal time for controversial issues (the **Fairness Doctrine**) and nonpartisan presentation of political candidates (**Section 315**). But, in general, the United States government always has been more interested in adhering to the free enterprise principle of competition than in invoking endless programming restrictions. The Federal Communications Commission felt that, in a relatively unencumbered marketplace, the best stations would survive, while the worst would be driven out of business.

Since commercial profit (not governmental information) was the major incentive, entertainment shows with mass audience appeal soon became the norm for American radio and television. Broadcasters had learned quickly that in a system where success is determined by public acceptance and advertising sponsorship only, it was best to create programming for what people liked rather than what programmers felt would be "good" for them.

Most other countries adopted a decidedly different philosophy toward their media production and distribution. Usually, these systems reflected variations on two basic concepts: **authoritarian** governance or **benevolent** policy.

The **authoritarian** framework viewed broadcasting as a method for infusing a government's political policies and goals into its people. It also geared its program production to provide the public with what they *should* see/hear (culture, information, education) rather than what they may *want* to see/hear. Entertainment programming in this context was seen as frivolous and wasteful, detracting from the primary goal of unifying the country toward a single political philosophy. Instead, news and cultural programming (sports included) were the primary emphases, and stations were under the direct control of the government.

Unlike the "intervention" principle found within the authoritarian framework, **benevolent** (or paternalistic) philosophers espoused a more moderate view of governmental involvement with the media. They believed that the state should not control all news and information outlets; rather, it should use its governmental influence to provide a balance between what the public *should* see/hear and what they *wanted* to see/hear. Accordingly, this could best be accomplished by having a government-run network as well as one or more privately owned (although government-regulated) networks.

Today's Broadcast Policies

Comparing today's world broadcast systems to those twenty--or even ten--years ago, the clear-cut delineations that identified countries as strictly authoritarian, benevolent, or competitive in nature have tempered considerably. The United States, for example, once known as the nation most representative of the competitive framework, has added a decidedly benevolent side to its basic character by supporting the notion of American public radio and television through the national programming of the Corporation for Public Broadcasting.

Beginning in 1967, after receiving a recommendation from the Carnegie Commission, the federal government inaugurated the Public Broadcasting Act. This legislation proposed monetary support for certain television and radio stations in their endeavor to provide quality programming to **alternative**, under-served audiences. They also spent time and money to "educate" the public to the notion that nonentertainment programming was not necessarily "non-entertaining." Since that time, public broadcasting has received additional support from other sources (including corporate underwriting and listerner/viewer subscriptions), but the basic premise of providing audiences with more educational, cultural fare has prevailed as the primary goal for noncommercial, government-supported American radio and television networks and their affiliates.

Conversely, many Western European countries that formerly advocated a strongly benevolent philosophy of media recently have allowed a more competitive element to emerge. This change has been evident in several ways. First and foremost, the growth of **Direct Broadcast Satellites (DBS)** and **cable television (CATV)** has broadened the marketplace of international programming and ideas. Second, more privately-owned networks or channels have emerged as a **counterprogramming** tool against the government-supported public networks. Finally, most of these benevolently-oriented countries have reaped economic benefits (through taxation, etc.) from the private ownership previously mentioned. Thus, competition has entered an area previously known as forbidden territory.

Even nations like The People's Republic of China and the USSR have changed radically from their firmly authoritarian broadcast policies of years past. Like the benevolent policy-makers, they have realized the economic potential of mass appeal programming as well as the growing difficulty of scrambling signals that come from other countries through DBS. But most important, they have been impressed by the increasing need for international communication in business, education, and diplomacy. There is no question that better understanding among

peoples will lead to more profitable relations between nation-states; and one way of achieving this goal is through media cooperation. Because of this recognition, past authoritarian policists gradually have become more benevolent in their broadcast practices.

TECHNICAL CONSIDERATIONS

In the early days of radio and television, American broadcasters, like the Federal Radio Commission, prioritized the technical dimensions of media most highly when planning for the success of a station/network. Programming in this context was clearly secondary to such areas as signal strength, amount of kilowatt power, clear channel status, and frequency assignation. Later, as television developed in the early fifties, the technical competition broadened to include color versus black-and-white TV, **UHF** television, videotape recording, and microwave transmission. The goal was to provide the most technically-aesthetic rather than the most content-rich broadcasts.

Not surprisingly, technology has been the most explosive element to change radio and television in the past several decades. Compared to the first years of broadcasting, for example, signal strength is no longer the major determinant of a good station. Today, broadcast signals are as strong on UHF television as on VHF TV. Relatedly, since 1964 (as dictated by the 1962 All-Channel Receivers Act), all television sets made for use in the United States have had capabilities for both UHF and VHF television.

In the area of radio, the technical differences between AM and FM radio seem to be diminishing somewhat. While FM radio is still an intrinsically better signal, the developments in AM stereo have been impressive.

As for the non-broadcast media, CATV and satellite television have had an enormous impact on programming strategies. Both technologies began as innovative methods to reach remote areas; but they have since emerged into predominant forces in radio and television scheduling. Satellite and cable now enable listeners/viewers to receive live, instantaneous transmissions internationally as well as nationally. They also can choose sources with programming that appeals to smaller, more specific audiences (often referred to as **narrowcasting**). Finally, viewers/listeners can look forward to the formation of new networks (including regional **superstations** as well as national organizations), thus changing the previous oligarchical control of CBS, ABC, and NBC. Because of technological development, then, there is more "equality" in radio and television today, making it possible to create more stations, more channels. . . and more competition among station owners.

STATION OWNERSHIP

Relatedly, to receive the greatest recognition (and financial reward) in broadcast programming and promotion, it was necessary to join forces with those organizations that could provide the biggest celebrity draw, the most sophisticated technical transmission, and the largest operating budget for daily expenses. Several commercial networks--Mutual (radio only), ABC (formerly the NBC Blue Network), CBS, and NBC--emerged as the primary means to success in both radio and television.

While the networks' ownership potential was severely limited by the **Rule of Seven** (an FCC stipulation which forbade ownership of more than seven AM stations, seven FM stations and seven TV stations),* other station owners found that they could reap large profits by simply **affiliating** themselves with the networks. Station affiliation involved a contractual agreement between the network and station (renegotiated every two years) that allowed the network to air its programming on sources other than its own stations. The network gained from the agreement because it could demand higher prices from advertisers for national coverage; it also could attract the biggest and brightest talent in acting, writing, and production, thereby keeping its advertisers and affiliates happy. The affiliated stations profited because they were practically guaranteed to have the most technically-aesthetic programming in their area. They also received a percentage of national revenues from network sales--without expending any costs up front--and they were able to demand higher revenues from local advertisers because of their association with a national production distributor.

Conversely, stations without a network affiliation (**independent programmers**) soon became severely disadvantaged. Since the broadcast media were relatively new, most productions for radio (and especially television) were original creations. Having limited funds (in comparison to the networks), independents often were confronted with the realization that they could produce only technically amateur programming. Television programmers also could choose old movies or kinescopic network reruns, but they still received the reputation of "poor relatives" by the networks and their affiliates. Some independent television programmers suffered worse fates: because they had been granted a channel on the UHF bandwidth, they were rarely or never seen by many viewers. That situation began to diminish steadily after 1964 (because of the FCC's 1962 **All-Channel Receivers Act**), but it still made for a dismal financial return--the

* The Rule of Seven was later amended to be the Rule of Twelve, thus expanding station ownership allowances to twelve AM stations, twelve FM stations, and twelve TV stations

independents consistently attracted smaller audiences and hence attracted fewer advertisers and smaller revenues. Moreover, there seemed to be no upward reversal in sight; for without improved technology, programming would suffer. . . and without improved revenues, improved technology would be impossible to obtain.

Unlike years past, today's radio stations no longer consider network affiliations necessary; and while an affiliateship is still very desirable in television, independent station programmers are no longer disadvantaged by poor signals and old or amateurish productions.

Presently, the essential competition between radio and television stations is programmatic, not technical in nature. All radio stations can obtain quality music and/or information packages via **syndication**, satellite, **special networks** (such as sports broadcasts and talk shows), and **shared production**, as well as from their own in-house work. Similarly, television stations can receive programming in **first-run syndication**, **off-network re-runs**, **shared production**, satellite programming, **special networks** (with movie packages, family entertainment, etc.), and quality local production. Thus, while network programming still leads in mass appeal, other high-quality program sources are available. This availability leads to a more competitive environment in radio and television. As a result, the success of a station often depends greatly upon the creativity of a good program director rather than solely upon the affiliateship to a network.

SUMMARY

These three factors--governmental policy, technical superiority, and station ownership--ruled broadcast programming for many years. However, within the past two decades, the areas of concern have changed somewhat. The successful station owner or network executive can no longer clearly establish superiority by technological investment alone. Moreover, since the development of recording and storage capabilities, programming has become increasingly available, affordable and accessible to everyone. Thus, the task of generating a creative radio or television schedule has become as important (if not more so) as those issues of ownership, government, and technology. As a result, a different perspective on the role of programming/promotion has evolved in broadcast management and operational philosophy.

Today, management executives seriously consider their overall image and creative role in mass communications distribution. Correspondingly, they accord significant recognition to those decision-makers who can provide potentially popular program fare. Programmers cannot do the work alone; however, they need people to promote creatively these shows as well as the overall image of the station/network.

CREATIVE SERVICES

Indeed, the rise in importance of programming has been accompanied by a similar rise in the area of promotion or "creative services." The past ten years has measured phenomenal growth in this area. The major reason? Programming is now the major selling point of a station or network. Correspondingly, it has become necessary to persuade viewers/listeners that Station A is better, brighter, and more desirable than Station B (if you represent Station A, that is). Also, a station/network's overall image must be established, nurtured, and promoted to impress upon the audience that a broadcaster (or cable operator) is an interested citizen of the community.

The person who oversees this combined campaign of show promotion and image enhancement is usually known as the promotion director or director of creative services. The promotion director usually maintains constant contact with all areas of station management so that he or she can be aware of any technological acquisitions, talent changes, community awards, new productions, etc., coming from the station or network. Based on this information, he or she generates the station image from three areas. These areas include **audience promotion**, **station promotion**, and **public relations** (see Figure 1.2). Sometimes a Promotion Director may have direct responsibility over a specific area, i.e., public relations, as well as the job of general overseer; sometimes he or she is solely accountable for the general image/program campaign. Whichever the case, it is important to maintain some overall direction, making sure that each area of a station's promotion is consistent and complementary.

The area of audience promotion includes on-air spots, merchandise (tee shirts, pens, ballons, etc.), print ads (in newspapers, magazines, television/cable guides, etc.), outdoor advertising (billboards, bus signs, etc.), and promotional gimmicks (contests, call-in shows, etc.). It is the area where the audience is the *direct* recipient of the message.

Station promotion utilizes some of the same merchandise found in audience promotion (e.g., paper weights, bumper stickers). But the primary recipients in this case are potential advertisers, who need to know research statistics and station history as well as the actual content of the programs being considered. To address these issues, promotion departments often serve as support services to time salespeople by devising press kits and other sales promotional tools to help attract clients to a specific show or show package. These materials are both logical and persuasive--and they are intended to convince potential advertisers that they will realize profit as well as image enhancement by buying timeslots on the station.

Let's say, for example, that a television station wishes to sell time for a series of games during the college basketball season. To supplement their gathering of audience research, ratings, and commercial package prices, the sales staff might also ask for help from Creative Services.

Figure 1.2. The avenues through which a station's image is created, generally the responsibility of the promotion director.

"Creative Services" in this context would mean a sales promotional role, i.e., to package important statistical information into attractive brochures, flyers, notebooks, etc. Promotion staff members might also be asked to prepare a multimedia presentation, either to be delivered as part of a large-scale tour of the station or to be given by a saleperson at an individual "pitch" meeting. The goal of station promotion, in either case, is clear: through station merchandise, brochures, press kits, and "media tours," salespeople must convince potential advertisers that they will make money as well as enhance their image by buying time on the station. And the promotion director plays an integral role in that process.

Public relations is directed primarily toward the media people who will report about the station/network in newspapers, magazines, and trade journals. Responsibilities in this area

include holding press conferences to announce a new program, a staff change, etc.; and crisis management, to resolve such problems as a controversial programming decision or union problem. Here, the promotion director must decide: 1) which media to contact [for placement of the article or press release)]; 2) whether some type of merchandising [tee shirts, pen sets, etc.] is appropriate; and 3) how the basic press kit can be better targeted toward the specific audience of newswriters.

Fundamental Strategies

All three areas of the image/programming campaign--audience promotion, station promotion, and public relations--use the same fundamental strategies for their specific "creative services." The only differences among these departments lie in the particular emphases given for the audience being served and the time of year for the campaign.

The three basic strategies are the following (see Figure 1.3):

1. **Acquisitive promotion**--used in the introduction of a new station, new station/network image, new series, or new programming lineup. The purpose is to inform the public of a change; and to encourage them to try the "new product." Each year, before the new fall TV season, the network audience promotion department usually distributes on-air spots, print ads, merchandise, and outdoor advertising to attract potential viewers. The sales staff augments the effort by providing press kits and merchandise for potential advertisers. And the public relations people finish the job by persuading journalists to write articles in the local papers and *TV Guide* as well as directing celebrity talk show tours and affiliate "weekends" with the stars (which provide local stations with individual video footage for their stations).

2. **Competitive promotion**--usually employed after a new show or station has been established, this strategy either directly or subtly compares itself to the programming of its competitors. For example, in 1987, ABC promoters urged viewers to, "Tape 'Cosby'--view 'Our World.'"

3. **Retentive promotion**--involves two areas of concern: programmatic retention and image retention. Retentive promotion concentrates, in the former area, on a positive **audience flow** (gradually increasing demographic shares) from one show to another, e.g., using the slogan, "Love in the Afternoon" to promote ABC's daytime dramas. Put more simply, stations or

networks are anxious to build audience numbers as the programming day progresses. Thus, retentive promotion encourages the audience to "stay tuned" for shows that promise to pique their interests in the same way as the previous show.

Retentive promotion, in the area of image creation, inspires loyalty to a certain station or network because it best serves its audience's needs regardless of day or time. A recent example of such promotion is the slogan, "Come Home to NBC."

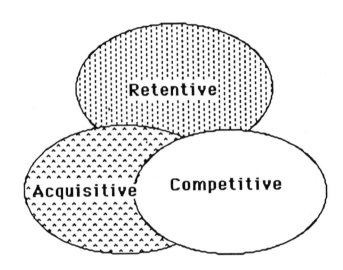

Figure 1.3. The three basic promotional strategies.

Together with promotion, programming defines the "character" of a station or network. And while new technologies such as **High Definition Television** (**HDTV**), compact discs and stereo TV will continue to develop, the essence of success always will show through creativity in programming and promotion management.

Chapter 2. How to Use this Book

As mentioned in the preface, the study of programming/promotion management can best be divided into two areas: understanding the *language* of the business, and exploring the *strategies* behind successful programming decisions. Much of the current textbook literature in radio and television already adequately defines the world of programming and promotion; thus, a clear-cut basis for discussion and understanding can be easily established. However, the nature of media programming/promotion goes far beyond a definition of terms. It is important to use other sources of information, along with definitional concepts, to formulate strategic approaches to radio and television scheduling.

Unfortunately, though, strategies often are difficult to formulate for several reasons:

1. Since the nature of programming and promotion is so changeable, textbook analyses of successful stations often become dated before they go to press.

2. Because of the nature of American broadcast media to copy winning strategies, it is often difficult to present a forum for truly creative thinking. That is, if Station A has been successful, why seek other alternatives?

3. Since there are no uniform rates for **syndication**, **license fees**, etc., it is difficult to present an actual case study that would be truly representative of a **large market** station, much less of smaller market areas.

Still, in order to become competent programming/promotional strategists, it is important to explore the day-to-day business of radio and television. One way to accomplish this is to analyze fictional (though factually-based) problems that affect many program managers today.

The purpose of this "working textbook" approach, then, is to emphasize today's challenges of programming/promotion rather than simply to provide a definitional framework for radio and TV scheduling. And, as the name of this text implies, your participation in analyzing these case study problems is indeed *active,* not *passive.* For each case, you will be given:

1. a description of the fictional station/network--its location, audience demographics, type of ownership or affiliation, past history (where applicable), and the context surrounding the current problem

2. a substantive definition of the problem

3. several relevant terms or concepts (presented in **bold face type**), which may be necessary to learn before solving the case study problem

4. a glossary that briefly defines each term listed in bold face type

5. line drawings or diagrams that may prove useful when creating your own programming/promotional strategy

6. a suggested discussion assignment that will help to broaden your perspective on the problem

7. the actual written assignment for you to assume as a programming or promotion director

Your job is to research as many sources as possible to determine the most workable solution to the problem. Remember, "creativity" is not the only element in programming/promotion decisionmaking. It is always necessary to consider the other dynamics of station/network operation: advertising revenue, technical restraints, station accountability to higher authorities, union agreements, talent availability, legal dimensions, etc. To help you in all aspects of your endeavor to adapt to the role of programming/promotion manager, suggested references in history, programming, promotion, new technologies, and management are provided.

HISTORY

While a brief "history" of each case study problem is presented in this workbook, you may find it necessary from time to time to investigate a broader historical perspective on the evolution of radio and television in the United States. The following books are highly recommended:

•Barnouw, Eric. *Tube of Plenty: The Evolution of American Television.* Rev. ed. New York: Oxford University Press, 1982.

•Brooks, Tim, and Earle Marsh. *Complete Directory to Prime Time Network Television Shows: 1946 - Present.* New York: Ballantine, 1987.

•Ebery, Philip K. *Music in the Air: America's Changing Tastes in Popular Music, 1920 - 1980.* New York: Hastings House, 1982.

•Foster, Eugene S. *Understanding Broadcasting.* 2nd ed. Reading, MA: Addison-Wesley, 1982.

•Head, Sydney W. and Christopher H. Sterling. *Broadcasting in America: A Survey of Electronic Media.* 5th ed. Boston: Houghton-Mifflin, 1986.

•Smith, F. Leslie. *Perspectives on Radio & Television: Telecommunication in the United States.* 2nd ed. New York: Harper & Row, 1985.

•Sterling, Christopher H. and John M. Kittross. *Stay Tuned: A Concise History of American Broadcasting.* Belmont, CA: Wadsworth Publishing, 1978.

GENERAL PROGRAMMING TEXTS

Each of the following references gives an excellent definitional framework for all areas of radio and television. You should consult them for more detailed information on such topics as general programming concepts, radio formats, independent stations, networks and their affiliates, and the effects of new technologies on programming:

•Clift, Charles, III, and Archie Greer, eds. *Broadcast Programming: The Current Perspective.* Washington, D.C.: University Press of America, 1980.

•Eastman, Susan T., Sydney W. Head, and Lewis Klein, eds. *Broadcast/Cable Programming: Strategies and Practices.* 2nd ed. Belmont, CA: Wadsworth Publishing, 1985.

•Howard, Herbert H., and Michael S. Kievman. *Radio and TV Programming.* Columbus, OH: Grid Publishing, 1983.

•Smith, V. Jackson. *Programming for Radio and Television.* Washington, D.C.: University Press of America, 1980.

RADIO PROGRAMMING

Sometimes, you may want to explore topics that are unique to radio only. Several excellent references already exist in this area, and newer sources will continue to emerge. Among the most respected texts for radio programming are the following:

•Bortz, Paul, and Harold Mendelsohn. *Radio Today--and Tomorrow.* Washington, D.C.: National Association of Broadcasters, 1982.

•Delong, Thomas. A. *The Mighty Music Box: The Golden Age of Musical Radio.* Los Angeles: Amber Crest Books, 1980.

•DeLuca, Mariann. *Survey of Radio Stations.* New York: Torbet Radio, 1983.

•DeSonne, Marsha L. *Radio, New Technology and You.* Washington, D.C.: National Association of Broadcasters, 1982.

•Keith, Michael C., and J. M. Crouse. *The Radio Station.* Stoneham, MA: Focal Press, 1986.

•Keith, Michael C. *Radio Programming: Consultancy and Formatics.* Stoneham, MA: Focal Press, 1987.

•Kierstead, Philip O. *All News Radio.* Blue Ridge Summit, PA: TAB Books, 1980.

•National Public Radio. *Listening to the Future: Cable Audio in the 80s.* Washington, D.C.: National Public Radio, 1982.

•MacFarland, David T. *Development of the Top 40 Radio Format.* New York: Arno Press, 1979.

•Paiva, Bob. *The Program Director's Handbook.* Blue Ridge Summit, PA: TAB Books, 1983.

•Routt, Edd, James B. McGrath, and Frederic A. Weiss. *A Radio Format Conundrum.* New York: Hastings House, 1978.

•Sklar, Rick. *Rocking America: How the All-Hit Radio Stations Took Over, An Insider's Story.* New York: St. Martin's Press, 1984.

TELEVISION PROGRAMMING

As in radio, television programming contains many issues that are specifically applicable to that medium only. Network affiliation, for example, has a much greater presence in TV than in radio today. Also, expanding channel capabilities as well as the growing costs of syndicated programming present alternatives as well as problems that are unique to the television program director. The following suggested booklist contains some excellent sources that address these topics:

•Bedell, Sally. *Up the Tube: Prime-Time Television and the Silverman Years.* New York: Viking Press, 1981.

•Blum, Richard A., and Richard D. Lindheim. *Primetime: Network Television Programming.* Stoneham, MA: Focal Press, 1987.

•Brown, Les. *Encyclopedia of Television.* New York: Zoetrope, 1982.

•Eliot, Marc. *Televisions: One Season in American Television.* New York: St. Martin's Press, 1983.

•Frank, Ronald E., and Marshall G. Greenberg. *Audiences for Public Television.* Beverly Hills, CA: Sage Publications, 1982.

•Frank, Ronald E., and Marshall G. Greenberg. *The Public's Use of Television: Who Watches and Why.* Beverly Hills, CA: Sage Publications, 1980.

•Gitlin, Todd. *Inside Prime Time.* New York: Pantheon, 1983.

•Levinson, Richard, and William Link. *Off-Camera: Conversations with the Makers of Prime-Time Television.* New York: New American Library, 1984.

•Morgenstern, Steve, ed. *Inside the TV Business.* New York: Sterling, 1979.

•Newcomb, Horace, and Robert S. Alley. *The Producer's Medium: Conversations with Creators of American TV.* New York: Oxford University Press, 1983.

•Nielsen, A.C. & Co. *The Television Audience.* Northbrook, IL: A.C. Nielsen & Co.; published annually.

•*Report on Prime-Time Television and Report on Daytime Network Television.* New York: Batten, Barton, Durstine & Osborn, Inc.; published annually.

PROMOTION

Compared to radio and television programming, media promotion sources often are difficult to find. There are, however, several references that prove most useful in both creative strategy and design or exemplify successful promotional campaigns:

•Berendorff, Fred, Charles Harrison Smith, and Lance Webster. *Broadcast Advertising and Promotion: A Handbook for Radio, Television and Cable.* New York: Hastings House, 1982.

•Eastman, Susan Tyler, and Robert A. Klein. *Strategies in Broadcast and Cable Promotion.* Belmont, CA: Wadsworth Publishing, 1982.

•Macdonald, Jack. *The Handbook of Radio Publicity and Promotion.* 2nd ed. Blue Ridge Summit, PA: TAB Books, 1981.

NEW TECHNOLOGIES

The growth of CATV and satellite television has caused new programming opportunities to emerge everywhere. Basic programming and promotional concepts and strategies remain

applicable to the new technologies, but it is important to explore their very unique differences from past broadcasting. Several sources address these specific issues quite well. Among them are the following:

•Besen, Stanley M., and Leland L. Johnson. *An Economic Analysis of Mandatory Leased Channel Access for Cable Television.* Santa Monica, CA: Rand Corporation, 1982.

•Carey, John. *Telecommunications Technologies and Public Broadcasting 1986.* Washington, D.C.: Corporation for Public Broadcasting, 1986.

•California Broadcasters Association. *Crystal Set to Satellite: The Story of California Broadcasting--The First 80 Years.* Sacramento, CA: California Broadcasters Association, 1987.

•Gross, Lynn Schafer. *The New Television Technologies.* 2nd ed. Dubuque, IA: Wm. C. Brown Co., 1986.

•Oringel, Robert S., and Sue Miller Buske. *The Access Manager's Handbook: A Guide for Managing Community Television.* Stoneham, MA: Focal Press, 1987.

•Rice, Jean, ed. *Cable TV Renewals & Refranchising.* Washington, D.C.: Communications Press, 1983.

•Shaffer, William Drew, and Richard Wheelwright. *Creating Original Programming for Cable TV.* Washington, D.C.: National Federation of Local Cable Programmers, 1983.

MANAGEMENT

As in all areas of radio and television organization, programming and promotion are intrinsically interwoven into the overall hierarchical structure. Some of your case study problems will directly involve management executives other than the program director or promotional manager; some studies will only tangentially relate to other areas of station management. Whichever the case, it is important to be aware of a station or network's complete operation--not just the programming and promotional components. Several informed sources exist on this topic, including those listed on the next page:

•Compaine, Benjamin M. *Understanding New Media: Trends & Issues in Electronic Distribution of Information.* Cambridge, MA: Ballinger Publishing, 1984.

•Durfey, Thomas C. and James A. Ferrier. *Religious Broadcast Management Handbook.* Grand Rapids, MI: Academie Books, 1986.

•Lavine, John, and Daniel Wackman. *Managing Media Organizations: Effective Leadership of the Media.* New York: Longman, 1988.

•Marcus, Norman. *Broadcast and Cable Management.* Englewood Cliffs, NJ: Prentice-Hall, Inc., 1986.

•McCavitt, William, and Peter Pringle. *Electronic Media Management.* Stoneham, MA: Focal Press, 1986.

ADDITIONAL SOURCES

Learning about the historical, technological, organizational, and theoretical backgrounds of programming/promotion is certainly necessary to understand the need for creative strategies in media today. However, because of the immediate nature of radio and TV, textbook information alone is not enough. More updated knowledge of trends and developments is often necessary. Therefore, the major concentration of your research should be on reading recent periodical material--yearbooks, magazines, newspapers, and journals--that most effectively reflect the new directions of media programming and promotion. The yearbooks most useful in this context are:

•*Broadcasting/Cablecasting Yearbook.* Washington, D.C.: Broadcasting Publications.

•*Cable Services Directory.* Washington, D.C.: National Cable Television Association.

Other trade magazines such as *Advertising Age, Billboard, Broadcasting, Broadcast Management/Engineering, Cable Marketing, Cablevision, Channels, Multichannel News, Television/Radio Age, Variety* and *View* will present current news of the programming and promotions industries as well as useful examples of successful station/network strategies. This

information should be most beneficial to you in seeking for sources to support your own point of view.

Nationally-distributed newspapers like *The Wall Street Journal, New York Times, USA Today* and *L.A. Times* also will be very useful in your programming research. But don't neglect another important source in this category--your local newspapers--which will provide invaluable information through their print ads, radio/television commentary, analysis of current social issues, and news about ownership/management changes.

As for scholarly analyses, most programming/promotional research can be found in the following journals:

• *Communication Quarterly*
• *Educational Broadcasting Review*
• *Feedback*
• *Journal of Broadcasting & Electronic Media*
• *Journal of Communication*
• *Journalism Quarterly*
• *Public Telecommunications Review*
• *Television Quarterly*

These sources will provide you with invaluable information on such topics as audience analysis, radio formats, cable concerns, and legal issues.

Finally, your research should include special attention to specific, "special issues" of *Broadcasting, Variety,* and other trade magazines, which provide information on programming areas like syndication show availabilities, production prices for prime-time TV programs, radio format trends, and the latest developments in technology. Samples of these listings appear in the Appendixes at the end of this book.

Given the number of research sources currently available in programming and promotion, you should have little trouble finding enough information for your case study problem analyses. You might, in fact, be overwhelmed by the amount of data that supports or refutes your strategy arguments. Therefore, to assist you in formulating your programming/promotion proposals, work-spaces with diagrams or line drawings are included in each case study problem. These aids will help you to organize your thoughts and structural layout for final presentation. They also will acquaint you with the resources and materials necessary to make responsible

scheduling decisions. So, after reading these problems and conducting your research, you should be completely prepared to adopt the role of program manager or director of creative services. Good luck. . . and good skills!

Chapter 3. Case Studies

Local Radio Case Studies

Case Study 1: Building the Image of a Long-Suffering MOR Station

This study features a flagship AM station which, until fairly recently, was very well respected for many years. Unfortunately, however, as times and owners changed, the goals and objectives became shaky and undefined. The new program director already has decided to move to an Adult Contemporary format; students are asked to create a strong image for the station through suggested playlists, personnel changes and promotional strategies.

BACKGROUND

KNML-AM is a 30-kilowatt station located in a small town in Montana. It was one of the first radio stations which began broadcasting to a Western audience in the mid-twenties age group. As with most stations in that era, KNML originally filled its broadcasts with a **general store** format, employing a **block programming** strategy rather than a single "sound."

However, with the advent of television in the early fifties, KNML drastically altered its programming philosophy and opted instead for a solid, **Middle of the Road** (MOR) music **format** with news and community-interest segments. Music selections from the **playlists** during this time included standards by Frank Sinatra, Perry Como, and Bing Crosby; and KNML maintained its network affiliateship for news and public affairs, as well as some of its popular radio personalities. In short, a typical **daypart clock** for KNML's format looked something like that shown in Figure 3.1.

Listeners responded well to the fifties' programming changes and, for the next twenty years, KNML maintained its same winning formula. As Vice President and General Manager Charles "Chip" Coffey said, "Why complicate a successful strategy? We've got the numbers, the attractive **demographics**, and a golden reputation."

Unfortunately, however, the numbers, attractive demographics, and golden reputation at KNML began to lose their sparkle in the early seventies. Along with the rise of FM stations

throughout the country came very specialized segmented music formats; and the newcomers in KNML's market area gradually started to erode the fortress KNML had built so carefully.

For the next decade, KNML chose to ignore the johnny-come-latelys, maintaining the same record list, staff announcers, and news and information features that had spelled success for three decades. But with each quarterly **Arbitron (ARB)** report, the numbers continued to drop. . . and finally became so low that even the most optimistic **ratings** period report showed KNML's share of the total listening audience to be no more than 10 percent. Considering that only three AM and four FM stations competed with KNML in its market area, Coffey decided that the numbers had plunged far below acceptable standards for his station. Consequently, he called in Programming "Doctor" Donna Newton for an analysis of the problem and her recommendation for change.

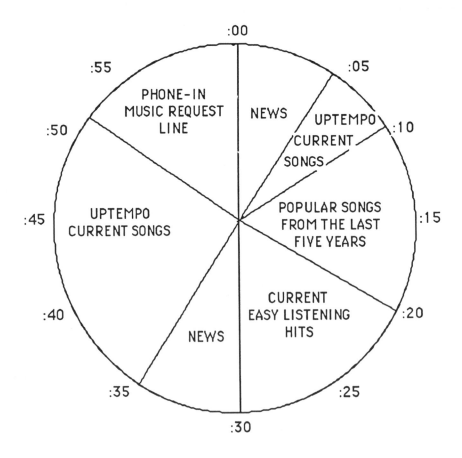

Figure. 3.1. Typical daypart clock for KNML-AM.

THE PROBLEM

Newton divided her analysis into four main areas: the competition, the competitions' strengths and weaknesses, audience demographics, and KNML's strengths and weaknesses.

The Competition

Newton listed KNML's competition accordingly:

1. KHHH-AM was founded in 1947. Operating at 1 kilowatt, HHH is a daytimer station that programs **Country and Western** music. While KHHH has a loyal audience, its share of the total listening market is very small. The last Arbitron quarterly report showed KHHH capturing only 8 percent of the total listening audience. However, when all aspects are analyzed, KHHH is doing remarkably well with its investment yield.

2. KPAL-AM began broadcasting in 1955, as a "PAL" to everyone. It operates at 1 kilowatt during the daytime, then reduces its power to 250 watts at night. KPAL has used a **Top Forty** format since its inception. In fact, PAL's promotion department has always emphasized that KPAL was one of the first stations to recognize Elvis Presley as a singing phenomenon. Its target audience is 12- to 25-year-olds, and the station maintains a hefty share of the total listening audience in every Arbitron report.

3. KJRE-AM is a 10-kilowatt station that first broadcast in 1959. JRE is known in the metropolitan area as the "personality" station, heavy on promotion and community participation. Its rise in popularity has been consistent since the early seventies-- precisely the same time period when KNML's ratings began to decline. KJRE is a Country and Western station.

4. KONJ-FM is co-owned with KHHH-AM. Its **Rock** format is popular with the young adult crowd, and it has been a solid numbers winner since its inception in 1977. KONJ operates at 43 kilowatts and "blasts" the sounds of hard rock farther than the other FM stations in the area.

5. KCRL-FM is the noncommercial, educational station in the area. It is affiliated with the local state university and operates at 17 kilowatts. Founded in 1965,

KCRL, like many noncommercial stations, broadcasts several formats during its operational day. They include **Black Radio**, **Jazz**, and Folk Music.

6. KMLA-FM began as a **Progressive** radio station in 1974. Operating at 3 kilowatts, KMLA has modified its programming somewhat throughout the last few years to widen its audience demographic from high school students to college students and young professionals. Today, the station's format could best be described as **Album-Oriented Rock (AOR)**.

7. KPBE-FM has been a standard **Beautiful Music** station since its inception in 1969. It operates at 30 kilowatts and has a consistent standing in Arbitron's quarterly ratings.

Station Strengths and Weaknesses

The first important factor in the success of a radio station is its kilowatt power capabilities. KHHH-AM and KPAL-AM are both low-powered and operate primarily in the daytime. This is bound to affect their overall audience **shares**. KMLA-FM is the least powerful FM station in the area; and not so surprisingly, its ARB ratings are substantially lower than its major competitor, KONJ.

As for format choice, most stations in this area have chosen to compete with each other by using similar programming strategies rather than by introducing new formats. Country and Western and Rock seem to dominate the radio dial. And, while the stations sharing these formats also must share the same audiences, the total percentage of people listening to each respective music type is very large in comparison to other format numbers.

KPAL has diverted a bit from the hard rock format, but it still has great popularity with college students; and, as the only Top Forty station in the area, enjoys a unique identity as well as high audience numbers. KPBE, on the other hand, has a small but loyal market group--the Beautiful Music admirers. KPBE may not compete well with KONJ in ARB numbers, but it has a solid identity as well as a solid return for the owners' investment.

KCRL is more experimental than the other stations; but as a noncommercial public radio affiliate, it can afford to be. KCRL provides valuable experience for aspiring

radio professionals, and, as such, encourages the trials of new and varied music types. While serving as a source for voices that otherwise would go unheard, KCRL certainly will never be a serious ratings threat for any of the commercial stations in the area.

Audience Demographics

KNML-AM's market area ranks 153rd out of the 214 market areas in the country. The racial distribution is as follows:
• 84% White
• 5.2% Black
• 10.6% Other (includes Hispanics and American Indians)

Principal industries include manufacturing, agriculture, mining, and tourism. The major manufactured goods are lumber and wood products, petroleum products, minerals, and farm machinery. Per capita income is $10,216. Unemployment ranks at 8.4 percent. The center of town hosts a state university with 9,200 students.

KMNL's Strengths and Weaknesses

Evaluating KNML, Donna Newton noted several strengths and weaknesses. The strengths included:

1. KNML's history and reputation as a community-oriented station

2. KNML's strong kilowatt power

3. KNML's "general appeal" format, which could potentially attract a larger audience demographic than at present

The major weakness of KNML (as seen by Newton) was its lack of foresight in adapting to the times, i.e., emphasizing the station's strengths, while at the same time modifying factors that detracted from its overall growth. The key element in KNML's continuing decline was not in its appeal to the substantial 25-50 age group; rather, it was in the failure to update its image, its **playlists**, and personnel to attract a wider audience demographic.

132,431

Thus, Newton recommended that the tradional KNML MOR format should be changed to an **Adult Contemporary** music station. The music playlist then could be changed gradually to attract a younger audience but not alienate the present faithful listenership. She also suggested that some **syndicated** satellite packages, such as Dr. Ruth Westheimer's popular talk show and Casey Kasem's "American Top Forty," be adopted into the programming schedule. These packages would add color and "slickness" as well as technical quality to the station.

Finally, Newton recommended that an intensive search be conducted for an **early morning drive-time** disc jockey or an announcing duo who would most successfully combine KNML's previous format with its newer, younger image. Together with the personnel changes, playlist upgrades, and syndicated satellite packages, of course, a new promotional campaign was definitely in order. The major focus of this campaign was clear: to combine KNML's former reputation of being "the reliable voice of the community" with its new goals of sharper technology, winning on-air personalities, national syndication, and overall quality programming.

SUGGESTED ASSIGNMENT FOR DISCUSSION

Successful promotional strategies may vary from market to market and region to region. For example, a medium-sized radio station in Lancaster, California (KKZZ-AM) had great success in its promotional attempt of a hot air balloon (with station call letters, of course) reporting the daily commuter traffic. Other markets found the idea intriguing but were unable to replicate KKZZ's success because of either inclement weather conditions or budget limitations. As a class group, analyze several different market areas around the country by reading some of the latest trade papers (such as *Variety* and *Billboard*). Do promotions in large radio markets differ significantly from those in small markets? Why or why not? Does a specific region affect overall promotional strategy? How?

WRITTEN ASSIGNMENT

Chip Coffey, after receiving Donna Newton's recommendations, has decided to change over to an Adult Contemporary music format. He also would like to investigate the feasibility of buying some nationally syndicated packages, although he knows that there is always a delicate balance between promoting the station as both community-oriented and nationally-syndicated. As Coffey's program director, outline a new plan for KNML, including a suggested music playlist, a personality profile for a new morning **drive-time** disc jockey (or team), and suggested non-music

features. Also, be sure to outline a brief image/programmatic promotion campaign for the station, which includes suggestions for **acquisitive** strategies, **competitive** strategies, and **retentive** strategies to attempt within the next six months.

To assist you in your assignment, the following form will provide an organizational framework for analysis. Be sure to address all the areas of programmatic and promotional concern by consulting a textbook and/or current articles in the periodicals mentioned in Chapter 2.

CASE STUDY 1: BUILDING THE IMAGE OF A LONG-SUFFERING MOR STATION

NAME _____ DATE _____

COURSE_____ PROFESSOR_____

SUGGESTED PLAYLIST

Give a brief description of the types of artists and songs that you would include in your suggested playlist for KNML's new Adult Contemporary format. Include the specific target audience and daypart you have in mind for each song (for example, Olivia Newton-John, "Let Me Be There," women 25-40, most likely programmed for mid-morning):

ARTIST SONG AUDIENCE DAYPART

EARLY MORNING DRIVE-TIME ANNOUNCER

This section should describe the type of early morning show that will attract and maintain a positive **audience flow** into the next daypart. Make sure that you indicate your target audience for this time block as well as the reasons why you feel your suggested disc jockey personality would appeal to them.

Disc Jockey Personality Profile:

NON-MUSIC PROGRAMMING

Indicate in this section, not only the types of non-music programming you would like to see on the "new" KNML, but whether these shows are syndicated or local.

Suggested Non-Music Segments (give a brief description and suggested time placement for each):

DAYPART CLOCKS

Using **daypart clocks**, you will best be able to illustrate your ideas about: 1) the suggested mix of talk and music throughout the broadcast day; 2) the balance between syndicated programming and local programming; and 3) the amount of news/public affairs you wish to broadcast during the various **time blocks**. As you know, KNML-AM is a 24-hour station. Therefore, you will be expected to define the times of day for each daypart, and to "section out"

the portions of time devoted to each type of programming you suggest. Here are your daypart clocks:

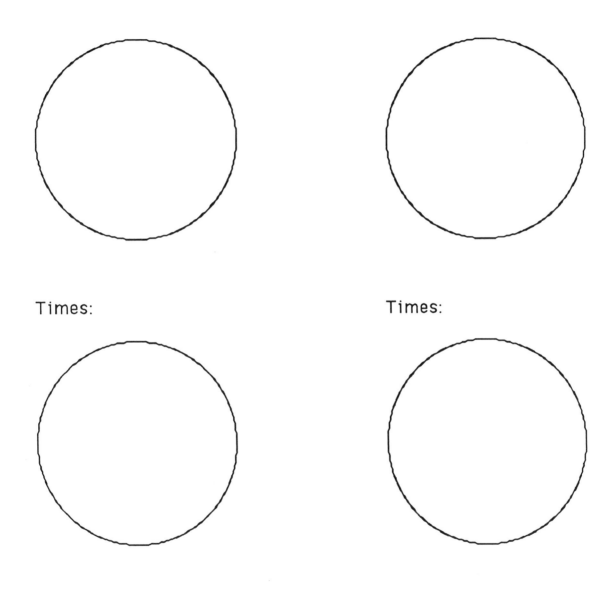

Times:

Times:

Times:

Times:

Figure 3.2. Daypart Clocks

Times:

Times:

Times:

Times:

Figure 3.2. (continued)

IMAGE/PROGRAMMATIC CAMPAIGN

Be sure to utilize your "campaign slogan" in all areas of your promotional campaign. Also, remember that each strategy (acquisitive, competitive, retentive) involves both image *and* programmatic dimensions.

Promotional Campaign Strategies

CAMPAIGN SLOGAN: _____

Acquisitive:

Competitive:

Retentive:

Case Study 2: Growing Up with the Baby Boomers

This study focuses on an FM station that began in the mid-seventies with a progressive format. Needless to say, while the anti-establishment "sound" was very popular during those times, today's audience of young professionals do not seem as interested in the "bad boy" DJs of yesteryear. Students are asked to formulate a programming strategy that still will appeal to the rebels of the sixties, but will target instead to the large yuppie audience--some of whom used to be rebels--in the community.

BACKGROUND

WALM-FM of Canterbury first started as a wacky, free-form **large market** Rock n' Roll station that earned a strong reputation for mayhem in the mid-seventies. This was due in part to the zaniness of its program director--"the Ayatollah of Rock'n'rolla," Stephen Taylor. Operating under Taylor's management, ALM featured shows like "Heroin Haven" and "Hot Tub Hotline" and ultimately lost its FCC license for playing tasteless songs about sex, religion, and drugs. As a result, a valuable FM frequency in a profitable **demographic** area soon became available to all interested bidders. After much consideration, Hagen and Associates, Inc.--a corporate conglomerate which already owned two AM stations and two FM stations in large and **medium-sized** markets--was chosen to purchase the station. Hagen and Associates was a relatively new **group owner** in media; but like many other companies, it was most concerned with "the bottom line," despite the fact that one of the reasons it had received WALM's license was that its corporate headquarters were located in Canterbury.

Following the purchase of WALM in 1983, Hagen and Associates decided to maintain the Rock n' Roll format. However, they cleaned up the station's general programming by hiring a respected program director named Paul Kelly, who offered more music in each daypart and milder talk shows at night. The morning **time block**, for example, usually looked like this:

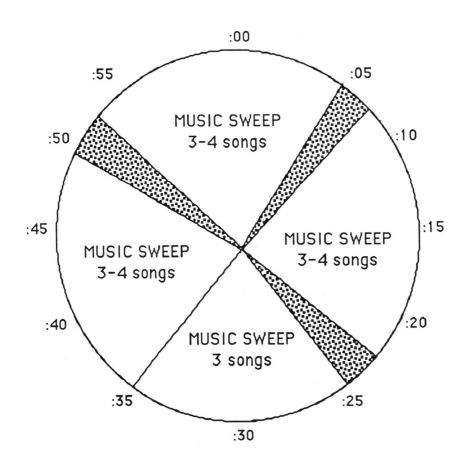

Denotes times for ad breaks

Figure 3.3. Typical morning daypart clock for WALM-FM.

The evening, however, replaced uninterrupted music with artist showcases like "38 Minutes With. . ." (a segment featuring music and interviews with a featured artist or group) or "Introducing. . ." (music and interviews with new groups in Canterbury) as well as updates of music news. WALM began, under its new ownership, to register gains in scattered **Arbitron** monthly **ratings**. However, the long-term results were not as encouraging. By 1985, the quarterly **ARB** figures began to decline steadily; and in Fall 1988, they hit an all-time low (by

registering a mere I.9 **share** of the Canterbury market). Consequently, after much thought and consideration, Hagen and Associates decided to drop the Rock n' Roll format.

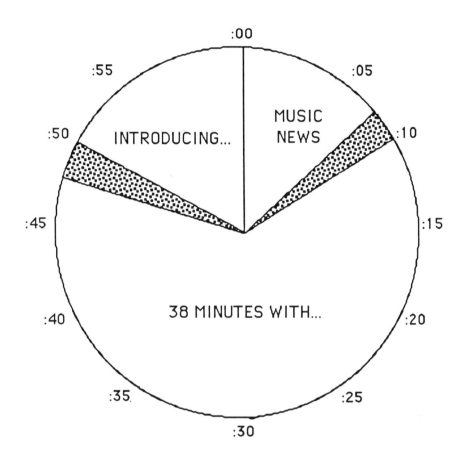

Figure 3.4. Typical evening daypart clock for WALM-FM.

WALM station personnel felt stunned and somewhat demoralized by Hagen and Associates' decision; for they had broadcast rock music for almost twenty years. Their first reaction was negative and defensive, accusing WALM's owners of not giving enough promotional

support to the station. Indeed, ALM had had a decidedly low profile and even Paul Kelly admitted that the station's main promotional tool was word of mouth (much like its Urban Contemporary competitor, WTUV). However, after a long, heated discussion, everyone finally agreed that WALM's days of rock n' roll should be over. The next step was to decide which new format to introduce and how the new format should affect ALM's audience and image.

THE PROBLEM

This market of approximately four million people comprises twenty-eight radio stations. Nineteen of them are on the FM dial; nine are AM stations. The format breakdown (along with the most recent ARB shares and kilowatt power assignations) is as follows:

AM Stations

--WBCD-AM:	50 kw, MOR (3.7)
--WCDE-AM:	20 kw, Adult Contemporary (2.2)
--WDEF-AM:	50 kw (day)/5 kw (night), Country (2.0)
--WEFG-AM:	5 kw, MOR (1.5)
--WFGH-AM:	10 kw, Inspirational (.7)
--WGHI-AM:	1 kw (day)/250 w (night), Black (1.2)
--WHIJ-AM:	5 kw, Adult Contemporary (2.7)
--WIJK-AM:	5 kw, All-News (1.1)
--WJKL-AM:	5 kw, All-Talk (1.1)

FM Stations

--WKLM-FM:	50 kw, Americana (3.5)
--WLMN-FM:	21.5 kw, Nostalgia (4.4)
--WMNO-FM:	17 kw, Alternative (1.8)
--WNOP-FM:	20 kw, Top Forty (3.4)
--WOPQ-FM:	1 kw, Educational (1.5)
--WPQR-FM:	50 kw, Black (5.2)
--WQRS-FM:	50 kw, Beautiful Music (6.0)
--WRST-FM:	34 kw, Jazz (1.6)
--WSTU-FM:	50 kw, Album Rock (9.2)

--WTUV-FM:	10 kw, Urban Contemporary (6.3)
--WUVW-FM:	20 kw, Religious (4.3)
--WVWX-FM:	25 kw, Top Forty (6.7)
--WWXY-FM:	34 kw, Adult Contemporary (8.2)
--WXYA-FM:	10 kw, MOR/Pop Adult (7.7)
--WYAB-FM:	10 kw, Classical (3.6)
--WYAC-FM:	12 kw, Beautiful Music (4.1)
--WYAD-FM:	61 kw, Urban Country (6.1)
--WZAB-FM:	28 kw, Album-Oriented Rock (8.9)
--WALM-FM:	27 kw, _____

Given these twenty-eight stations, we need not consider seriously the nine AM stations because collectively, they represent less than l5 percent of the total audience. Two of the FM stations are noncommercial and are therefore competing for different audiences than those in which WALM has yet shown interest. Thus, we should begin to explore the remaining stations and their composition.

Traditionally, the main competition has come from the album rock stations, which have always earned good ratings numbers. However, according to Paul Kelly, "These stations offer more than enough of that kind of programming for Canterbury." The Top Forty stations include one that has been around since the early seventies as well as one that has been formed quite recently, which splits the potential audience of teenagers and young adults. The remaining competitive stations, including WALM, all have broadcast transmission power that ranges between l0 and l00 kilowatts (more than adequate for reaching Canterbury's metropolitan market). These stations have programming that ranges from Middle-of-the-Road music to formats like Adult Contemporary, Nostalgia, Urban Country, Beautiful Music and "Americana." As Paul Kelly says, "What WALM has to do is find something new and different for a town that has it all."

Hagen and Associates agree. They have also suggested that Kelly consider the possibility of integrating some popular satellite programs and syndication services into his final format decision. Depending upon WALM's new sound, examples of such programming include "Rockline," American Country Countdown with Bob Kingsley," "American Top Forty with Casey Kasem," and "The Comedy Show" (hosted by Dick Cavett). Many syndicated/satellite

packages are available today, and they generally cost less than to employ a full staff of disc jockeys. Therefore, they should be explored as part of the overall picture when formulating a plan for WALM-FM's most profitable program direction.

SUGGESTED ASSIGNMENT FOR DISCUSSION

Look at all the satellite programming services that are available on your radio dial today, and answer the following questions:

1. What are the advantages these satellite programming services offer to station owners?

2. What are the advantages these packages offer to the listening community?

3. What are the disadvantages of satellite program services to station owners?

4. What are the disadvantages of these packages to the listening community?

5. How does the growth of syndication/satellite services affect programming decisions?

6. Will syndication/satellite services ultimately change the image of radio as a "local" medium? Why or why not?

7. How will these packages impact upon those persons who are planning or pursuing a career in radio?

WRITTEN ASSIGNMENT

Assume the role of Hagen and Associates' hired consultant. Develop an overall strategy that will turn WALM around and please the upper management as well as utilize the station's present substantial resources. Remember, radio is a business. Which format choice you make or whatever combination of formats you devise will have to be part of a plan that fits most comfortably in all facets of programming, promotion, and sales.

Once you've chosen your format and explained why it will work, be sure to include a *brief* campaign outline for promoting the new station image.

Note: To provide more information to help you better determine your format plan, here is an official list of formats found in *Broadcasting Yearbook:*

-- **Adult Contemporary**

-- **Agriculture and Farm**

-- **Album-Oriented Rock**

-- **Alternative**

-- **Beautiful Music**

-- **Black**

-- Bluegrass (See **Country and Western**)

-- Bright (See **Middle of the Road**)

-- Christian (See **Religious**)

-- **Classical**

-- Concert (See **Classical**)

-- Conservative (See **Middle of the Road**)

-- **Contemporary Hits**

-- **Country and Western**

-- Easy Listening (See **Middle of the Road**)

-- Farm (See **Agriculture and Farm**)

-- Folk (See **Progressive**)

-- French

-- **Golden Oldies**

-- Good Music (See **Beautiful Music**)

-- Gospel (See **Religious**)

-- Hard Rock (See **Progressive**)

-- Hit Parade (See **Top Forty**)

-- Informational (See **Talk** and **Religious**)

-- Instrumental (See **Beautiful Music**)

-- Interview (See **Talk**)

-- **Jazz**

-- **Middle of the Road**

-- **All News**

-- Nostalgia (See **Golden Oldies**)

-- Oldies (See **Golden Oldies**)

-- Personality (See **Talk**)

-- **Progressive**

-- **Religious**

-- Request (See **Top Forty**)

-- Rhythm and Blues (See **Black**)

-- Rock (See **Top Forty**)

-- Sacred (See **Religious**)

-- Soul (See **Black**)

-- Spanish

-- Standards (See **Middle of the Road**)

-- **Talk**

-- **Top Forty**

-- Underground (See **Progressive**)

-- Uptempo (See **Middle of the Road**)

-- Urban Country (See **Country and Western**)

CASE STUDY 2: GROWING UP WITH THE BABY BOOMERS

NAME _____ DATE _____

COURSE_____ PROFESSOR_____

FORMAT CHOICE: _____

RATIONALE:

SUGGESTED "BALANCE" BETWEEN LOCALLY-PRODUCED PROGRAMMING AND SYNDICATED/SATELLITE SHOWS

RATIONALE:

SUGGESTED PLAYLIST

Give a brief description of the types of artists and songs that you would include in your suggested playlist for WALM'S new format. Include the specific target audience and daypart you have in mind for each song (for example, Supremes, "Stop in the Name of Love," men and women 25-40, most likely programmed for early evening):

<u>ARTIST</u> <u>SONG</u> <u>AUDIENCE</u> <u>DAYPART</u>

NON-MUSIC PROGRAMMING

Indicate, in this section, not only the types of non-music programming you would like to see on the "new" WALM, but whether these shows are syndicated or local.

Suggested Non-Music Segments (Give a brief description and suggested time placement for each):

DAYPART CLOCKS

Using daypart clocks, you will best be able to illustrate your ideas about: 1) the suggested mix of talk and music throughout the broadcast day; 2) the balance between syndicated programming and local programming; and 3) the amount of news/public affairs you wish to broadcast during the various time blocks. As you know, WALM-FM is a 24-hour station. Therefore, you will be expected to define the times of day for each daypart, and to "section out" the portions of time devoted to each type of programming you suggest. Here are your daypart clocks:

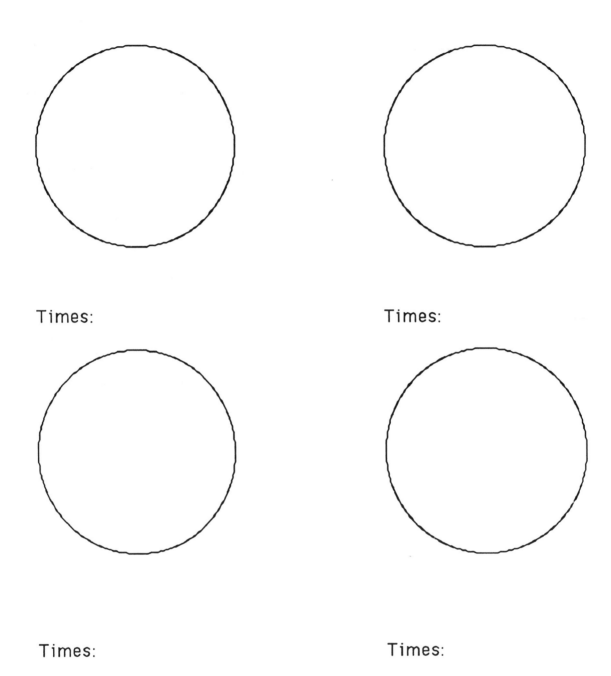

Times:

Times:

Times:

Times:

Figure 3.5. Daypart Clocks

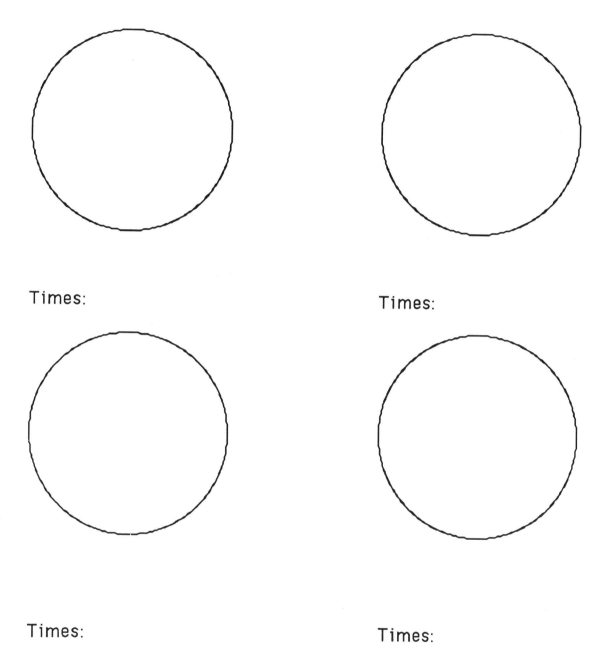

Times:

Times:

Times:

Times:

Figure 3.5. (continued)

IMAGE/PROGRAMMATIC CAMPAIGN

Write a brief description of a campaign strategy that might be used to "kick off" WALM's new format. Be sure to use your suggested campaign slogan when addressing each strategy.

Promotional Campaign Strategies

CAMPAIGN SLOGAN: _____

Acquisitive:

Competitive:

Retentive:

Case Study 3: Creating a New Station in Kirkwood

A small-business owner recently has decided to purchase a modestly successful Top Forty FM station in a medium-sized market. Students are asked to assume the role of research assistants, describing their methodologies for finding the audience demographics of the community. They should also indicate how they would gather data for an "ascertainment of needs" statement as part of the client's programming proposal to the FCC.

BACKGROUND

Because of the finite nature of the electromagnetic spectrum, the availability of AM and FM frequencies is understandably limited. Therefore, when a station goes up for sale, the owner usually can expect to receive several attractive offers for his or her vacant frequency space.

However, since airwaves are viewed as "public property" (by the Communications Act), the final decision of station ownership does not rest solely upon the previous license holder. Instead, all interested parties are invited to apply to the FCC for the available frequency space. Included in each application are statements of financial stability and social responsibility, as well as a list of other current media holdings. The FCC also requires each applicant to submit a detailed programming proposal that describes a station format committed to serving the public "interest, convenience, and necessity."

To develop a strong programming proposal, substantive research must be conducted beforehand in the community. Usually, this research addresses the following areas:

1. **ADI Market Ranking** of the broadcast coverage area

2. the **demographic** characteristics of the community (including total populations as well as statistical breakdowns of age, gender, economic status and educational level)

3. developing trends within that demographic population (i.e., the community experiencing rapid growth over the last several years, the population becoming demographically "older" or "younger," etc.)

4. the average per capita income (including unemployment statistics within the community)

5. the average educational level of the total population

6. the number of radio stations, television stations, and newspapers available to the community

7. the number and type of higher educational institutions in the area

8. the geographic terrain of the broadcast market (i.e., flat land vs. mountains, the identity of a border town near Canada or Mexico, etc.)

9. the community's major industries

10. statistics about and characteristics of other stations in the ADI Market (including formats, operating power, total hours of the broadcast day, and AM vs. FM)

11. the strengths and weaknesses of each competing station

12. an ascertainment of public needs within the community, stating which of these needs have been met and which have not

To gain adequate information about each area, two types of research--primary and secondary--are used. **Primary research** involves data-gathering through surveys, focus groups, and/or experiments. The information usually is current, community-based, and specifically applicable to the local station; therefore, it is conducted either by the station personnel or by outside

researchers. **Secondary research**, on the other hand, is the process of locating data already available, either in station files or the local library.

Primary Research

As mentioned above, there are three methods of conducting primary research: surveys, focus groups, and experiments.

A **survey**, quite simply, is a data-gathering technique that presents a set of questions to a group of respondents. Usually, this group is chosen as a representative sample of the entire population; and from its answers, a station owner can decipher both strengths and weaknesses within his or her broadcast community. The survey technique is probably the most popular method in primary research (because of the wide use of ratings services). Surveys can be conducted in one of three ways:

1. telephone surveys

2 face-to-face interviews

3 mail surveys

Extreme care should be taken in each case to make certain that the research sample is representative, the proper questions are asked, and the respondents are not predisposed to any bias in their answers.

Focus group research, unlike the survey method, is not concerned with sophisticated sampling procedures or "quantifiable" statistical analysis. Rather, its purpose is to collect groups of people with similar interests and conduct in-depth, face-to-face discussions with them. Subject matter in these discussions might include topics like a station's image, format, or on-air personalities; and a designated moderator leads these groups by using a general outline. However, if the discussion evolves into subjects other than those originally presented, the moderator usually is flexible enough to accomodate the new information.

The final category of primary research, **experimental research**, is generally conducted by special interest groups (such as academics, behavioral institutes, etc.) to determine the effects of media on social behavior. These groups employ an empirical method, using control groups to study specific cause-and-effect relationships. Examples of such research include expansive topics like "violence on television," as well as more limited areas of interest like the

importance of a laugh track in a comedy series. Ordinarily, most broadcasters do not utilize experimental research when ascertaining the needs of their own communities. Nevertheless, it is important to mention it, because many topics evolving from this type of primary research often get discussed in focus groups.

Secondary Research

Many answers to the demographic questions raised earlier can be found in published sourcebooks and periodicals, which are available in libraries or data centers. Among the most commonly used resources for secondary research are the following:

1. Industry Organizations:
 - Broadcast Promotion and Marketing Executives
 - National Association of Broadcasters
 - National Cable Television Association
 - Radio Advertising Bureau
 - Television Bureau of Advertising

2. References:
 - *Broadcasting/Cablecasting Yearbook*
 - *Standard Rate and Data Service*
 - *Survey of Buying Power*
 - *Television Factbook*

3. Census Data (found from these sources):
 - College and university faculty
 - Federal government bureaus
 - Local libraries
 - Private data companies
 - State data centers

THE PROBLEM

WCMK-FM, a 44-kilowatt radio station located in Kirkwood (a **medium-sized** market in the South), has enjoyed a respectable reputation since its inception in 1941. Begun as a

simulcast stepsister station to its **Middle-of-the-Road** AM counterpart, WCMK-FM subsequently developed its own identity as a popular **Top Forty** station in the late sixties. Since then, CMK has battled competitors with similar **formats** in the market area, but has continued its modest Top Forty popularity despite the growing competition.

☐ Denotes Kirkwood's metropolitan area

▨ Denotes the remaining coverage area

Figure 3.6. WCMK-FM's coverage area in the Kirkwood market.

Recently, however, Harnegie International, the corporation owning WCMK-AM and FM, decided to divest itself of Kirkwood's FM station. This was because Carl Harnegie, the founder

and chief executive officer of the corporation, had just acquired a 51-kilowatt FM station in the Midwest, thus exceeding the FCC's ownership cap of twelve FM stations. Harnegie was then left with the dilemma of deciding which of his previous stations to drop. Assessing the profit and loss statements for each of his twelve FM holdings, Harnegie decided that WCMK-FM, while showing a reasonable profit margin, was not living up to the potential he felt the station possessed. Also, since Harnegie International's home offices were located in the Midwest (where, incidentally, most of its other radio and television stations were found), Harnegie felt that the corporation could exert greater control in daily station management with stations closer to the home offices. Thus, WCMK-FM soon became registered on the FM station auction block.

Hearing about Harnegie International's decision to sell WCMK-FM, hordes of potential buyers rushed to apply for the available FM license. The applicant pool included several large corporations as well as a few smaller businesses. Among the small businesses was a tiny manufacturing firm, Harriet Jerome, Inc., based in Kirkwood.

Before applying for her FM license, Jerome needed to research the **demographics** in Kirkwood as well as her potential radio competition in the market area. This way, Jerome would be better able to determine the most profitable way to serve the radio public's interest, convenience, and necessity.

SUGGESTED ASSIGNMENT FOR DISCUSSION

Redefine the basic areas of **primary research**--telephone surveys, face-to-face interviews, mail surveys, focus groups, and experimental research--and then discuss the strengths and weaknesses found in each.

WRITTEN ASSIGNMENT

You have been hired as Harriet Jerome's research assistant. She has raised several questions about the Kirkwood community and WCMK's relationship to it. Your job is to gather the necessary demographic information to answer these questions, thus supplementing Jerome's programming proposal to the FCC. Use the spaces provided to indicate the research method(s) you would employ to gather the data for each question. Be sure to include the following: a) an identification of the research as either **primary** or **secondary**; b) if using primary research, the specific type you would employ as well as some sample questions; and c) if using secondary research, the sources you would use to gather your data.

CASE STUDY 3: CREATING A NEW STATION IN KIRKWOOD

NAME _____ DATE _____

COURSE_____PROFESSOR_____

Significant research questions in preparation for a programming proposal:

1. What is the demographic breakdown of Kirkwood and its immediate surroundings?

2. What seem to be the population trends of the area; i.e., is Kirkwood a "growing area" or is it "leveling off?" Is the population "aging" or becoming "more youthful?"

3. What is the average per capita income of Kirkwood? What is the average educational level of its population?

4. What are Kirkwood's major industries?

5. How many AM and FM stations exist in Kirkwood?

6. Which of these stations could be considered competitors and which would not? Why?

7. What are the "basic statistics" of WCMK's competitors (AM versus FM station, level of operating power, **daytimer** versus 24-hour station, format, etc.)?

8. What are the competition's strengths and weaknesses?

9. Are there any needs not currently being met by the existing radio stations in the Kirkwood community?

10. What type of balance should exist between music and non-music programming in the community?

Case Study 4: Providing an Outlet for Alternative Radio

Students are asked to apply the special considerations of noncommercial radio to a small community station that has just become available in their market area. Prior to deciding upon an actual format, they must analyze their audience and determine if there are needs not being met by the present grouping of commercial and noncommercial stations in the community.

BACKGROUND

Non-commercial radio sometimes has suffered the reputation of being seen as a "poor substitute" for commercial broadcast stations. And, in point of fact, most noncommercial radio outlets have lower power, lower budgets, and lower economic goals; because they are organizations that depend heavily upon volunteer help and donations. However, as many communities have discovered over the past several years, noncommercial radio can become extremely popular despite its economic limitations. This is because noncommercial radio, without the severe pressure of being a profit making business, is freer to provide **alternative** formats to those audiences who would not be otherwise served.

Noncommercial radio began in 1922, with the formation of WHA, an educational station located on the campus of the University of Wisconsin. In subsequent decades, the FCC recognized a need to expand this type of alternative outlet and used its Educational Broadcasting Branch to encourage the growth of noncommercial public radio, television, and other services. Later, in 1967, a governmental funding program was set up for such broadcast stations. Accordingly, based on a recommendation by the Carnegie Commission, a network known as **National Public Radio (NPR)** was formed. While not affiliated with all non-commercial stations, NPR nonetheless was seen as a means for raising the overall status of public broadcasting throughout the country.

The basic mission of public broadcasting today is to provide an alternative to commercial programming. This doesn't mean that all programming should be instructional or highly cultural; instead, the definition of "alternative radio" encompasses any type of programming within a market area that is not being serviced elsewhere.

According to Michael Keith,* four basic station categories currently exist in noncommercial radio. He classifies them accordingly: 1) **public** (affiliates of the NPR network), 2) **college** (low-powered educational AM and FM stations used mainly as training laboratories for future broadcasters), 3) **community** (generally low-powered facilities providing specific services, which would not otherwise be available in the community), and 4) **religious** (low-powered community stations with very specific Christian formats).† Of these four categories, **public** radio stations are the least numerous; for they comprise only about 25 percent of the total number of noncommercial operations in the United States today. The reason for the lack of NPR affiliates is simple: most noncommercial stations are unable to meet the basic requirements for associating themselves with the network. It should be noted, however, that these smaller, noncommercial stations are just as serious about their programming and community service as are their NPR cousins.

To become a National Public Radio affiliate, several essential qualifications must be met. First, the noncommercial station must employ a full-time staff of at least five professionals on twelve-month contracts. Second, its operating budget must exceed $80,000 (to maintain the existing staff and equipment). Third, the station should broadcast programming for at least eighteen hours each day, 365 days a year. Fourth, an FM facility must operate with a minimum of 3 kilowatts of power (and an AM station should be powered for at least 250 watts). Finally, an NPR affiliate should have at least one production studio as well as a control room.

Needless to say, the economic requirements alone often discourage most "noncomms" from affiliating with NPR. Despite their lack of affiliation, however, noncommercial radio stations still receive many benefits because of their alternative programming potential.

Records, tapes, and CDs, for example, are relatively easy to obtain because record promoters usually see noncommercial radio stations as free-thinking and open to more creative music concepts. As such, many innovative formats (like New Wave) can be market-tested

*Michael C. Keith, *Radio Programming: Consultancy and Formatics* (Stoneham, MA: Focal Press, 1987), pp. 177-188.

†Noncommercial, low-powered, religious stations should be distinguished from *Christian formatted* stations, which are typically commercial and quite profitable.

without a great amount of monetary risk. Thus, most record promoters are anxious to establish as good a relationship with noncommercial stations as with their commercial counterparts.

THE PROBLEM

When starting a new alternative format, you must consider the needs of the community and whether or not they are being addressed adequately. Remember, the purpose of noncommercial radio is not to repeat the programming strategies and formats already established; rather, it is to experiment with new and potentially better ideas for the listening public. Therefore, to assess the community's needs and desires, the following questions must be answered:

1. How many other stations exist in the market area?

2. How many are AM stations; how many are FM outlets?

3. What is the format, the operating power, and the length of broadcast day for each station?

4. How well do they compete with each other?

5. Are there any groups whose educational, informational, or musical needs are not being met adequately?

6. Is there adequate support for an alternative format?

Finally, after determining the general community demographics and specific community needs, certain questions must be asked about the alternative station's goals and strategies:

1. Who comprises the **target audience**(s) for your alternative station?

2. Should the alternative station be **block programmed** or **format programmed**?

3. How long should the broadcast day last in order best to meet audience needs in an economically expedient way?

4. What should the typical broadcast day look like (hours, specific programs, music choices, news, etc.)?

5. If music-oriented, how definitive should the playlists be?

6. Should the station be automated? If so, how completely should it be automated?

SUGGESTED ASSIGNMENT FOR DISCUSSION

Analyze the programming strategies of your own college radio station or of a noncommercial station near you. Have small groups of students listen to each **daypart**; then critique the chosen playlist, staff announcers, non-music segments, and overall community image. Does the station meet the needs of the public it serves? Does each daypart contribute to a consistent overall image of the station? Why or why not?

WRITTEN ASSIGNMENT

A 2-kilowatt, noncommercial radio station license has just become available in your community. Based on the demographics, existing commercial and noncommercial station competition, and perceived format needs in your market area, develop a proposal which includes the following:

1. an analysis of audience demographics in your area
2. trends of potential demographic growth or change
3. income and educational averages per capita
4. industries and means of economic potential
5. media competition (TV stations as well as radio)
6. audience needs and their perceived success at being met
7. the strategies and goals for your proposed station

Some of this information easily can be found in industry publications like *Broadcasting/Cablecasting Yearbook* or from existing census data in your local library. However, in other cases (most notably in the area of community needs), you probably will turn to **primary research** for your principal data. One technique used often in primary research is the **survey** method, where a representative sample of the community is given a questionnaire to determine the strengths and weaknesses of existing stations in the area.

When putting together a questionnaire, several stages of preparation are necessary. They include:

1. selecting an adequately representative sample for your questions
2. designing the questionnaire
3. coding the data
4. analyzing the data.

To assist you in each stage of your survey development, the following general checklists are provided. Using these guides, you should be able to formulate your most important questions, while at the same time understand the inherent limitations of gathering data through survey methodology alone.

1. SELECTING A REPRESENTATIVE SAMPLE FOR YOUR QUESTIONS.

__/ This sample will include _____ people, which represents_____%
of the total population.

__/ The demographic breakdown is representative of the
community.

__/ I have chosen the following method for interviewing
my representative sample:

1) _____ Randomly chosen telephone numbers

from a directory.

2) _____ Randomly chosen telephone numbers

without a directory.

3) _____ Personal interviews in a public place

(such as a shopping mall, bus stop, etc.).

4) _____ direct mail survey.

2. DESIGNING THE QUESTIONNAIRE.

___/ I have included the appropriate informational space for data
about the age, gender, education, marital status and
income level of each respondent.

___/ I have included any other necessary informational space about
the respondent for my survey (list any other categories if
applicable):

___/ I have written a brief opening statement which invites my
respondents to answer the survey. It includes an
explanation of the questionnaire as well as a polite thank
you for their time and cooperation.

___/ My questions are positioned in a logical, easily understandable
manner. Usually, the question order for surveys is as
follows: 1) broad, easy-to-answer responses that elicit a

person's interest; 2) less interesting (and less threatening) questions; and 3) more sensitive and/or more open-ended questions.

___/ I have decided to ask open-ended questions.

___/ I have decided to ask pre-coded/closed questions.

___/ I have decided to incorporate both open-ended and closed questions in my survey.

3. "CODING" THE DATA.

___/ I have adequately defined my demographic breakdowns. For example, does "Group 1" include 1-10 year olds or 1-12 year-olds?

___/ I have adequately defined my "codes" on the questionnaire. For example, does "1" mean "most important" or "least important?"

___/ For open-ended questions, I have identified specific "watchwords" to note on the survey.

4. ANALYZING THE DATA.

___/ I have collected and summarized all statistical data.

___/ I have included specific individual comments (if available) to better describe my statistical findings.

___/ I have written my overall conclusions about the survey, making sure to include the inherent limitations within this method of research.

Examples of the survey method abound in all areas of broadcast research. The following excerpt was taken from a questionnaire designed to assess the popularity of TV soap operas

among different age groups. Despite some of its very obvious weaknesses (which you may want to discuss in class), it illustrates the familiar format of questionnaire construction.

DAYTIME PROGRAMMING QUESTIONNAIRE

Interview Number: ____ Age: ____ M F

1. When you have a "free" afternoon during the week, how do you usually spend your time? (LIST ACCORDING TO PREFERENCE, WITH "1" INDICATING "MOST OFTEN;" "5" INDICATING "LEAST OFTEN")

____ watching television
____ doing work in your house/apartment
____ going to a film
____ doing some outside activity (specify)

____ other (specify)

NOTE: IF YOU INCLUDED "WATCHING TV"
 AS "1" OR "2," PLEASE PROCEED.

Figure 3.7. A typical questionnaire format for broadcast research surveys.

Local Television Case Studies

Case Study 5: Reconditioning a Rusty Independent

Students are asked to address the problems of an independent UHF station that was innovative in the early days of television but has fallen into a creative slump. For one thing, more independents are now in the area, with more diverse programming for diverse audiences. Further, CATV and home video recorders now provide other outlets for televised entertainment. A definite updating in product and image is needed.

BACKGROUND

Twenty-five years ago, the world of television was associated with a very different technological environment than the one in which we live today. For one thing, most TV stations were located on the **VHF (Very High Frequency)** bandwidth, broadcasting on Channels 2 through 13 only. Also, these outlets were most likely affiliated with one of the "big three"--NBC, CBS, or ABC. Thus, programming and channel selection were fairly uniform in all major areas of the country.

Things began to change, however, as the demand for more stations grew. The VHF bandwidth soon became insufficient to meet increasing needs, leaving **UHF (Ultra-High Frequency)** as the only available outlet for possible station expansion. UHF was a technological boon to broadcasting, because it enlarged the potential channel capacity from twelve to eighty stations. On the other hand, programmers soon discovered that mere channel expansion was hardly enough to ensure economic success. This was due to several factors:

1. Most television receivers were unable to pick up the UHF signal. Originally, TV sets were designed to receive VHF signals only; to receive UHF stations, it was necessary to

purchase a $20 attachment and special antenna for signal conversion. (Note: This began to change later, when the FCC ruled in the **All-Channel Receivers Act** that all TV sets sold after May 1964 were required to pick up all channels, VHF and UHF. But the "VHF only" condition remained much later than 1964, since most people did not rush out to buy a new television set. . . especially if UHF conversion meant only one additional station in their community.)

2. The signals received from early UHF stations were less powerful and somewhat less stable than those from VHF stations. This was because the VHF signal was intrinsically stronger than the UHF bandwidth. And, in the early sixties, television technology had not advanced enough to compensate for UHF signal stability variations.

3. Most television viewers were already in the habit of watching programs on the established VHF stations. Viewers had become comfortable seeing certain performers, newscasters, and talk-show personalities and were unlikely to switch, unless the alternative was clearly more attractive.

4. Since most VHF stations were either network-__affiliated__ or __owned and operated (O & O), their programming budgets were much more liberal than those for the newly-formed independents__. As a result, TV shows on VHF were more glamorous and technically "slick," utilizing many expensive on-location sets as well as nationally-recognized celebrities (some of whom they had helped to create). UHF, with limited monies and an unestablished track record, could not begin to compete at the same level.

THE PROBLEM

Despite their rather disadvantaged position, however, several independent UHF stations in the early sixties decided to confront the competition; and they succeeded admirably in providing popular programming, even with seemingly overwhelming odds against them. Among these stations was WJCM-TV (Channel 43), in Lynchville--a **large market** area located in the midwestern United States.

WJCM entered the Lynchville metropolis in 1964, competing with three established VHF stations and one other UHF (which was noncommercial). At that time, JCM's programming competition looked like this:

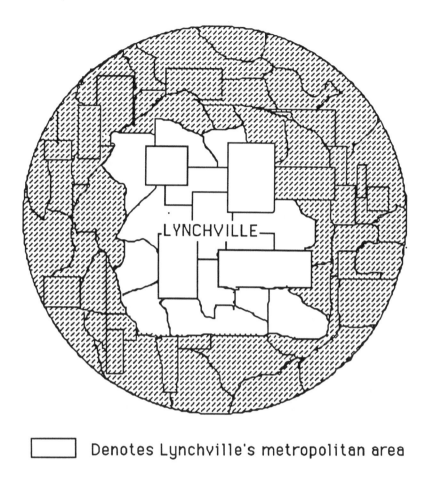

⬜ Denotes Lynchville's metropolitan area

▨ Denotes the remaining coverage area

Figure 3.8. WJCM-TV's coverage area in the Lynchville market.

MORNING

	6:00	6:30	7:00	7:30	8:00	8:30	9:00	9:30	10:00	10:30	11:00	11:30
2	Mighty Mouse	TV Seminar	Three Stooges			Popeye	Ed Allen Time	Amos & Andy	Young Marrieds	Andy of Mayberry	Get the Message	Missing Links
4	Off-air		Today Show				Honey-Mooners	Bachelor Father	Ann Southern	What's This Song	Concen-tration	Jeopardy
7	Off-air	Sunrise Semester	Key Club	Captain Bob	Captain Kangaroo		Romper Room	Girl Talk	Mike Wallace	Price is Right	The McCoys	News, Weather
52	Off-air											

AFTERNOON

	12:00	12:30	1:00	1:30	2:00	2:30	3:00	3:30	4:00	4:30	5:00	5:30
2	Father Knows Best	Truth or Consequ.	Trailmaster		General Hospital	Day in Court	Movie				Hercules	Lloyd Thaxton
4	News, Weather	Mike Douglas Show			Loretta Young	The Doctors	Another World	You Don't Say	Match Game	Clubhouse 4	Movie	
7	Love of Life	Search For Tom	News	As The World T.	Pass-word	House Party	To Tell The Truth	Edge of Night	Secret Storm	Bozo the Clown		Jack Benny
52	Off-air	Kindergarten	Off-air								Kindergarten	

EVENING

	6:00	6:30	7:00	7:30	8:00	8:30	9:00	9:30	10:00	10:30	11:00	11:30
2	News	Love That Bob	Rifle-man	Voyage to the Bottom of the Sea		Patty Duke	Shindig	Mickey	Burke's Law		ABC Scope	News
4	News	NBC News	Seahunt	90 Bristol Court			Movie				News	Regis Philbin
7	News	CBS News	One Step Beyond	To Tell The Truth	I've Got A Secret	Andy Griffith	Dick Van Duke	Cara Williams	Danny Kaye		News	Off-air
52	Off-air	Back-grounds	World History	Pathfinder	French Chef	Museum Open H.	Int'l Magazine		Spec-trum	The Comers	Off-air	

*NOTE: THE PRIME-TIME SCHEDULE IS ACTUALLY TAKEN FROM A WEDNESDAY NIGHT IN 1964.

Figure 3.9. 1964: A typical TV programming day in Lynchville. The prime-time schedule is actually taken from a Wednesday night schedule in 1964.

WJCM's first task, under the guidance of its new station manager, Matt Barr, was to determine the "programming holes" in the market. Barr wanted to know what the viewers of Lynchville wanted to see on television but weren't getting. The results of his survey (conducted by an independent research company) were quite definitive: Lynchville viewers overwhelmingly responded that sporting events, especially basketball games, were not being broadcast often enough. Accordingly, in the first year of WJCM's programming, Barr provided his viewers with forty-eight professional and college basketball games, college football and hockey, area high school football and basketball, big-time wrestling, bowling, and horse racing. To supplement sports programs, WJCM also broadcast "The Little Rascals," "Jack Lalanne Exercises," "Burns and Allen," "Superman," "I Love Lucy," old Westerns, cartoons and movies.

MORNING

	6:00	6:30	7:00	7:30	8:00	8:30	9:00	9:30	10:00	10:30	11:00	11:30
43	Off-air						Little Rascals		Jack Lalanne	Movie: Dialing for Dollars		

AFTERNOON

	12:00	12:30	1:00	1:30	2:00	2:30	3:00	3:30	4:00	4:30	5:00	5:30
43	Movie, cont.		The Dorothy Nelson Show			Sky King	Sergeant Preston	Bugs Bunny		Rocky and Bullwinkle Show		Popeye

EVENING

	6:00	6:30	7:00	7:30	8:00	8:30	9:00	9:30	10:00	10:30	11:00	11:30
43	Burns & Allen	I Love Lucy	Super-Man	Movie/Sporting Event (In Season)					Lynchville Talks Sports		Off-air	

Figure 3.10. 1964: WJCM-TV's typical TV programming day.

In addition to his emphasis on sports programming, Barr also tried to introduce a "personality symbol" for a *total station image*--someone who would serve as a representative of Channel 43's commitment to the Lynchville community. Months passed as he searched everywhere in the city for the right person. In fact, some of his friends began to call him, "Matt O. Selznick," since his quest began to resemble the famous producer's worldwide casting call for the proper "Scarlett O'Hara" in "Gone With the Wind!" In the final analysis, Barr's choice for the job was a woman named Dorothy Nelson;.and for fifteen years, until her death in 1979, she was the "voice" of Channel 43. Tall and slight, with an extremely broad educational background, Nelson broadcast a 90-minute talk show five days a week, discussing topics that ranged from politics to poultry preparation. Nelson's discreet combination of a soft delivery with her biting wit was a real crowd pleaser. Consequently, through her unique personality, Dorothy Nelson captured the hearts of Lynchville as well as an identity for Channel 43.

The first three years of broadcasting were a constant struggle at WJCM, and several newswriters even predicted the demise of the station. However, just as everyone was beginning to lose hope, all of Matt Barr's creative efforts were finally rewarded. For the first time in its brief history, **ARB** reports revealed that Channel 43 had actually topped one VHF station in the area, and needless to say, the station personnel had good reason to celebrate.

Since then, WJCM has continued to be a competitive force in the Lynchville metropolitan area, being recognized as a local programmer as well as a solid citizen in the community. Despite Channel 43's apparent success, however, two factors have affected Lynchville's market since the early sixties: 1) three new UHF independents have since opened their doors, competing for sports, old movies, and sitcoms; and 2) cable recently has come to Lynchville, bringing with it even more competition from the **superstations** outside the market area. This growing number of competitors have led Station Manager Barr to feel that now, more than ever, WJCM needs a strong image--an image that reminds viewers that Channel 43 is a leading voice in Lynchville The strategy has obviously worked in the past, and Barr has every reason to believe it can happen again. As he stated in a recent meeting, it doesn't matter whether Channel 43 decides on a personality-oriented image (as with Dorothy Nelson) or on a distinct programming image. Whatever the case, JCM should move forward to lead in the future as it has led the past.

To understand WJCM's problems more clearly, it is important to analyze the station's competition more specifically. The following pages illustrate a typical day's television schedule in

Lynchville. From the listings, it is easy to see that TV viewers have a wide range of programming choices already.

MORNING

	6:00	6:30	7:00	7:30	8:00	8:30	9:00	9:30	10:00	10:30	11:00	11:30
43												
2	News		Good Morning America				Lynchville, A.M.		Geraldo		Fam.Ties	Net.soap
4	Net news	News	Today				Will Shriner show		Hour Magazine		Wof Fort	Scrabble
7	Ready to Go		This Morning				High Roll.	Blackout	Nancy Lynch		Price is Right	
25	Off-air	Macron I	Top Cat		Dinosaucers		Casper	Diet Now	Movie			
27	Off-air		PTL Club		Fat Free		Jimmy Swaggart		700 Club		Success-N-Life	
52	Off-air		Sesame Street		M.Rogers	Sesame Street		M.Rogers	Instructional Programming			
57	Transformers		Dennis	B.Bunny	Flintstone	Jem	Popeye		Mighty Mouse		Headline News	
A&E	A&E Preview		Golden Age of TV		Footsteps		Previn		Movie			
BRV	Off-air											
DIS	Mickey	Mousercise	Pooh Corner	D. Duck	Dumbo	Schooner			Good Morning		Walt Disney Pres	
ESPN	Aerobics	Nation's Business Today				SportsCenter		Windsurfing		Light Side	Fishin' Hole	
HBO	Survival		The Pilot	Fr. Rock	Movie				Movie			
MAX	Movie, cont.		Movie				Movie					Movie
MC	Movie, cont.		Movie					Movie				
SHO	Movie, cont.		Movie				Michael Jackson		Movie			
TBS	News	Tom & Jerry's Funhouse			Bev. Hill	Hazel	Little House		Movie			
USA	Diet Rite	Makeover	Cartoons					Movie				
WGN	Alice	Faith 20	Muppets	Jem	Bionic 6	Teddy Ruxpin		Munsters	Jeanie	Best Talk	Perry Mason	
WOR	Rom. Rm.	Zoob. Zoo	Smurfs	Jetsons	B. Bunny	Dinosaucers		F Troop	Benson	Marcus Welby		C. Burnett

Figure 3.11. Today: A typical TV programming day in Lynchville.

AFTERNOON

	12:00	12:30	1:00	1:30	2:00	2:30	3:00	3:30	4:00	4:30	5:00	5:30
43												
2	News	ABC Soap Operas							Donahue		Oprah Winfrey	
4	News	People are Talking	NBC Soap Operas						Magnum P.I.		Peop. Ct.	4 Live
7	News	CBS Soap Operas							Pyramid	Holly.Sq.	Live at 5:00	
25	Dukes of Hazzard		CHIPS		Defender	Cartoons					XX Dare	H.Days
27	Barnaby Jones		Movie				TBA	Sup Ct.	Movie			
52	Sesame Street		Instructional Programming		Painting	Hometime	Sesame Street			M.Rogers	□ 1 TV	3-2-1
57	G.Times	That Girl	Hazel	Jeanie	Cartoons						Brady Bunch	
A&E	Love and Money		50s TV	Creativity		Wld Sur	Movie				Love and Money	
BRV	Off-air											
DIS	Movie					Pooh Corner	Willows	Ed.Twins	D. Duck		Little Friend	
ESPN	PGA Golf						LPGA Golf					
HBO	All The Rivers Run				Movie			Movie			Movie	
MAX	Movie, cont.		Movie			Movie				Movie		
MC	Movie, co	Movie				Movie				Movie		
SHO	Movie				Movie				Jo's Song	Movie		
TBS	Perry Mason		Movie				Tom & Jerry		Flintstones		Brady Bunch	
USA	That Girl	Any 4 $	Pyramid	Your Luck	GI Joe	Jackpot	Reaction	Munster	Bumpers	Dance Party, USA		
WGN	Geraldo		News		D.V.Dyke	Beaver	8 is Enough		Little House		Cheers	
WOR	News		H Roll.	Love Con.	Cannon		Vega$		Barnaby Jones		Rockford Files	

Figure 3.12. Today: A typical TV programming day in Lynchville.

EVENING

	6:00	6:30	7:00	7:30	8:00	8:30	9:00	9:30	10:00	10:30	11:00	11:30
43												
2	News		ABC News	Focus	ABC Prime-Time Programming						News	Nightline
4	News		NBC News	PM Mag.	NBC Prime-Time Programming						News	Tonight
7	News	CBS News	Jeopardy	Wof For.	CBS Prime-Time Programming						News	Ent. Ton.
25	Movie, cont.		Untouchables		Movie				Benny Hill		Late Show	
27	TBA		Current Affair		Movie				Money How to Make It			
52	McNeil-Lehrer		Julia Child	Survival	Old House	Say Bro.	PBS Prime-Time		News	Bus. Rpt.	Off-air	
57	3's Co.	Webster	F of Life	Taxi	Movie/Sporting Event (In Season)				News		MASH	F Troop
A&E	50s TV	Trvl Magazine		Wld Sur	Movie				Amanda	All Creatures G/S		50s TV
BRV	Off-air				Movie				South Bank Show		Movie	
DIS	Movie			Cat/Hat	Best of Disney		Movie				Ozzie	
ESPN	LPGA Golf		SportsCenter		'73 Best of 4		College Basketball					
HBO	Movie, cont.		Movie				Movie				Movie	
MAX	Movie			Movie			Movie			Movie		
MC	Movie, cont.		Movie				Movie					
SHO	Movie, cont.		Movie				Movie					
TBS	Alice	C Burnett	A Griffith	Sanford	Movie/Atlanta Sports (in season)					3 Stooges	Audubon	
USA	Cartoons		Airwolf		Movie						Airwolf	
WGN	Fof Life	WKRP	Cheers	B Miller	Movie				INN News	Twi. Zone	Star Trek	
WOR	Magnum P.I.		Pyramid	B Miller	Eve. Mag	Movie/New York Sports (in season)						News

Figure 3.13. Today: A typical TV programming day in Lynchville.

LATE NIGHT

	12:00	12:30	1:00	1:30	2:00	2:30	3:00	3:30	4:00	4:30	5:00	5:30
43												
2	Hill Street Blues		Div. Ct.	The Judge	News	Dynasty		Hit Sq.	Lynchville, A.M.		Focus	News
4	Tonight	David Letterman		News	PM Mag.	Hawaii Five-O		Real P.	People Are Talking		Before Hours	
7	Movie					TBA	News	Nancy Lynch		CBS News Nightwatch		
25	I Love Lucy		Off-air									
27	TBA		Off-air									
52	News		Off-air									
57	INN News	After Hrs.	Off-air									
A&E	All Creatures G/S		Movie					Movie				
BRV	Movie, cont.		Movie					Off-air				
DIS	Movie				Off-air							
ESPN	Auto Racing		Fishin' Hole			Sports	SportsCenter		Off-air			
HBO	Movie, cont.		Movie					Movie				
MAX	Movie, cont.		Off-air									
MC	Movie, cont.		Off-air									
SHO	Michael Jackson		Movie					Movie				
TBS	Movie				Movie				Headline News			
USA	Movie				Movie				Bob Newhart			
WGN	Magnum P.I.		TBA									
WOR	Simon & Simon		Joe Franklin		Home Shopping							

Figure 3.14. Today: A typical TV programming day in Lunchville.

WJCM's budget is not as large as that of the network affiliates, but with the amount of programming available today, including **first-run syndication**, reruns, **co-ops**, **franchise** programs, movies, cartoons, and sports--as well as local production--the station should be able to have a distinct image while remaining profitable.

To further illustrate this point, the following station profiles describe the experiences of three large-market, independent program directors. Their brief statements, listed below, make it is easy to visualize the wide range of strategies available for competing in the TV demographic marketplace:

Station A

This television market includes four independents, as well as the three network affiliates and a strong public station, competing for a share of the audience. Station A is the "newest kid on the block," having been introduced only seven months ago. There was no question, when Station A began broadcasting, that an aggressive policy was in order to compete favorably with the other stations in the area. Station A's major move was to sign secondary affiliate contracts with all three commercial networks: CBS, ABC, and NBC. This meant that Station A had the option either to run network programming that was pre-empted or not broadcast by the primary affiliate stations.

Amassing over ten prime-time movies in the first four months of Station A's **secondary affiliate contract**, the independent also cleared two network soap operas and game shows from all three networks. By complementing Station A's lineup with network programming, the program director hoped to separate Station A from the other independents as well as to compete favorably with the network affiliates.

Another way of distinguishing Station A from the other competition was to form a partnership with a local FM station. This way, both stations were able to promote each other through shared contests and promotions.

Finally, Station A felt a need to have a special set of personalities associated with it. Since the station scheduled no news in its programming line-up, a "good will" spokesperson campaign was launched so that Station A would have identifiable personnel visiting schools, hospitals, nursing homes, etc.

Using network-quality programming, local radio station promotion, and friendly public relations, Station A made a quick impression in its large metropolitan area, and was lauded for its creativity in a crowded television market.

Station B

Station B is one of four independent stations in a seven-station market. As such, it must not only provide alternative programming to the networks, but also **counterprogram** three other indies.

Station B formerly spent most of its time analyzing the network schedule--and then "guessing" at which series would last long enough to go into syndication. However, with the networks cancelling so many shows after a short turn, this task became dubious at best.

Consequently, Station B has adopted a rather unique strategy, consisting of analyzing the most popular network programming in its market area; and then approaching producers of such shows after they have been cancelled to see if they will go on syndicating to individual markets. Sometimes the strategy works--and sometimes it is less than successful. However, with triumphs such as the past hit, "Fame," Station B is confident that it can maintain a high quality yet continue to distinguish itself from other stations in the market.

Station C

Station C has devoted itself to local programming. In fact, more than eleven hours per week (excluding news) of locally-produced material is available in both prime- and nonprime-time in this large metropolitan market. For example, talk/variety shows provide a good alternative to other programming scheduled in the late afternoon, because they appeal to a wide audience and are likely to sustain themselves for many years.

Personnel at Station C know that every programmer's wish list is somewhat different, depending on what has worked in the past and what is working in the present. But they firmly believe that a station's true success will

rest with its highly identifiable reputation as a local programmer--not with its ability to choose popular syndicated programming.

SUGGESTED ASSIGNMENT FOR DISCUSSION

Identify, describe, and analyze the television stations available to viewers in your community. Are they **independent**; **affiliated** with a network, network owned and operated (**o & o**); **superstations**, or cable networks? How many hours do they air programming each day? Do they have clear identities (i.e., as "movie stations," "sports broadcasters," etc.), or do they simply **counterprogram** to other stations? What is each station's commitment to local programming? How successful is each station (in **ratings**)? How would you rank each station in terms of overall worth to your community?

WRITTEN ASSIGNMENT

Describe a proposed typical programming day at WJCM (which runs from 7:00 AM to 1:00 AM). Be sure to include the following:

1. a rationale for your proposal
2. specific program descriptions and their sources (**co-op**, rerun, **first-run syndication**, etc.)
3. a promotional campaign strategy for your new image

Note: You will be able to find a great deal of information about syndication availabilities from lists in trade publications. A sample of such data is illustrated in the Appendix of this book; however, for more updated information, you should visit your local library.

CASE STUDY 5: RECONDITIONING A RUSTY INDEPENDENT

NAME _____ DATE _____

COURSE _____ PROFESSOR _____

RATIONALE FOR PROGRAMMING STRATEGY:

PROPOSED PROGRAM LISTINGS FOR WJCM

Include the production source (co-op, rerun, etc.) as well as a program description if necessary.

TIME	PROGRAMTITLE/DESCRIPTION	SOURCE

<u>TIME</u>	<u>PROGRAM TITLE/DESCRIPTION</u>	<u>SOURCE</u>

IMAGE/PROGRAMMATIC CAMPAIGN

Be sure to utilize your "campaign slogan" in all areas of your promotional campaign. Also, remember that each strategy (acquisitive, competitive, retentive) involves both image *and* programmatic dimensions.

PROMOTIONAL SLOGAN: _____

Acquisitive:

Competitive:

Retentive:

Case Study 6: Pulling the Plug on Promotion

Students are asked to consider the alternatives when a promotion manager irresponsibly places a controversial ad in print and on-the-air. Are the long-term consequences negligible or can they be significantly damaging?

BACKGROUND

Channel 12 (KDBS) is a network-affiliated station located in the Western city of Dunford. Dunford is a **large-market** metropolitan area which lists manufacturing as its principal industry. Other important statistics about Dunford (gathered from U.S. census reports) include the following:

Population: 1,018,609

Population density: 15,046 per square mile

Population growth: -19%

Population over 65: 13.1%

Population under 35: 51.6%

Average income per household: $22,198

Average cost of houses: $61,000

Area: 67.7 square miles

Employment: 1,051,500 (in metropolitan area) employed;
 12.3% unemployment

Transportation: 2 major airports; 2 railways; subway system;
 major port

Communications outlets: 5 TV stations, 20 radio stations, 2
 newspapers

Medical facilities: over 70 hospitals

Educational facilities: 4 major universities, 15 community
colleges

Figure 3.15. Original organizational hierarchy for KDBS Channel 12.

For its first two decades of programming, Channel 12 enjoyed a great reputation as being one of the most community-minded broadcasters in the region. This image started early in the development of Channel 12. And it continued to expand, due to the first owners of KDBS, who were committed to quality *local* television at any price, despite their **network affiliation**. They also inaugurated a station policy that no management executive was unapproachable. As a result of their high ideals, hard work, and superior broadcast skills, Channel 12 soon became one of the most talked about **affiliate** stations in the TV industry. It gained national prominence and often was featured in trade journals and video mags as "the type of station any city would be

proud to have." Accordingly, many other large market programmers often made pilgrimages to Dunford to uncover the "secrets" of good (and profitable) local television.

Along with these programmers who sought advice from Channel 12 came prospective buyers--large corporations who were interested in acquiring KDBS as part of their group ownerships. Not so surprisingly, they courted the station in grand style, offering Channel 12's original owners huge sums of money. . . as well as promises that the station's programming policies would not be altered drastically. Administrators spent months and months of consideration of both "pledges" and monetary offers, KDBS eventually became part of a **group ownership** named Martin MacNamara, Inc.

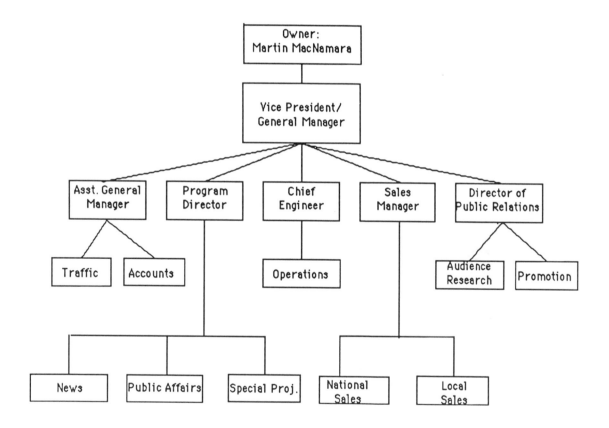

Figure 3.16. Organizational hierarchy for KDBS under Martin MacNamara, Inc.

Unfortunately for the citizens of Dunford, however, Martin MacNamara's promises were not as serious as everyone had hoped. Less than a year had passed before the programming schedule of KDBS had changed drastically, and public affairs shows were whittled down to the bare minimum. Further, most of the local personalities at Channel 12 were encouraged to make way for new personnel, and the organizational hierarchy became much more complicated and unwieldy.

Ultimately, after four years of group ownership in Channel 12, Martin MacNamara, Inc. decided to invest in another area of the country. They subsequently sold KDBS to yet another corporate group owner, Compudyme, which was more interested in profitable spreadsheets than in local commitment. Thus, Channel 12 evolved (within a relatively short period of time) to a corporate-run business, complete with slick but unfamiliar personalities and station personnel.

Among the new station personnel ushered in by Compudyme was a thirty-year-old promotion director named Andy Wayne. Wayne had worked at several stations before he had come to Dunford, but he had never worked in this region before; nor had he ever been in a middle management position. Consequently, he came to Channel 12 with a decidedly different philosophy of promotion than had been previously expressed.

People in all areas of creative services at Channel 12 had been encouraged to include subtlety, sophistication, and a "family" image in their promotional work. Andy Wayne, on the other hand, favored a more overt, "hit 'em over the head" approach. He thus decided that the best way to introduce his difference in philosophy was to tackle the next big project himself, showing his employees how well the "more direct" approach could work.

THE PROBLEM

Very little time had passed before Wayne was given the chance to demonstrate his strategies of promotional exposure. A news anchor had just come to town, and part of her responsibilities included the creation of several "showcase" investigative reports during the sweep months of February, May, July, and November. Wayne immediately seized this opportunity to demonstrate his skills and took charge of the first featured investigative report--sex education in public schools--which aired during a sweep week in February. The local news competition during this same week included:

1. a week-long feature series on "looking good," including exercise suggestions, diets, fashion, etc.

2 a comparison between lifestyles in the Eastern and Western United States, including economic, social, and political perspectives

3. a reflective look at how far women have come in the workplace/domestic world from pre-World War II to the present

Unfortunately, the new news anchor at Channel 12, Nicole Espen, was not used to working directly with creative services, so Andy Wayne did not have much access to the film footage of Espen's report. Not to be deterred from his goal, however, Wayne decided to forego the process of looking for specific quotes from the report and chose, instead, to use a provocative headline: "Today I have learned to have safe sex." The TV/radio and print ads also featured a little girl (about nine years old) beside this quote.

Andy Wayne was pleased with this approach; he felt it would grab the attention Channel 12 was looking for. He also felt that, as promotion director, he was under no obligation to discuss the ad with Espen, the news director, the program director, or even the general manager. He simply logged the ad in the Channel 12 programming schedule, sent the audio version to several radio stations, delivered the copy to local newspapers and TV scheduling books, and waited for a reaction from the people of Dunford. He was convinced that this new, aggressive strategy would prove his point that promotion should be direct. . . and daring.

Unfortunately, Wayne received a much greater *negative* reaction than he had anticipated. Shortly after the ads were released, management was confronted by several special-interest groups holding demonstrations at the station. One group in particular was led by a Baptist minister who said he had great trouble explaining the ad to his confused eight-year-old daughter.

A lengthy discussion with the protesters followed, and then the station manager decided to pull the TV/radio spots and print ads. The news series continued to run, but the station manager decided that before the next investigative feature would air, Channel 12 would have to formulate a specific policy regarding the station's promotional philosophy, interaction with other departments, and accountability in other areas of station management.

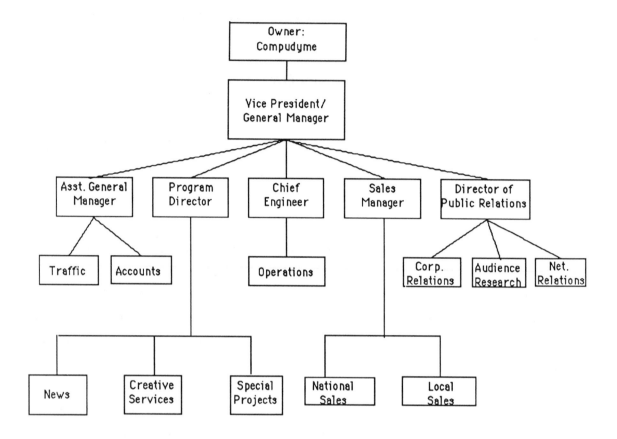

Figure 3.17. Organizational hierarchy for KDBS under Compudyme.

SUGGESTED ASSIGNMENT FOR DISCUSSION

Because promotional styles often differ from station to station, it is important to look at the various strategies available. Students should divide into small research groups. Each group should focus on a specific TV station within the community and analyze all the forms of promotion it releases for a week (i.e., print, radio, TV, billboards, etc.).

Groups will research each station in the area, and then a discussion should follow. It should include these questions:

1. What elements of promotion do all of these stations share?

2. How does each differ?

3. Does there seem to be a consistent station image running through all of its promotional work?

4. What are the advantages of controversial promotional work? What are the disadvantages?

5. What are the advantages to a more subtle approach to promotion? What are the disadvantages?

6. How much time and budget money should be spent in promotion? Does this decision depend on each individual program? Why or why not?

WRITTEN ASSIGNMENT

Based on your discussion, develop a three-to-four page policy statement for Channel 12. Include the following:

1. a statement of the general goals of promotion
2. the need for programmatic promotion as well as promotion of overall station image
3. the interrelationship between programming and promotion
4. your suggested organizational hierarchy for promotional approvals (including a rationale for the proposed structure)

Case Study 7: Is It Really a "Good Morning Stephenston?"

This study addresses the advantages and disadvantages of producing a local show versus buying syndicated programming fare. Students are asked to consider renewing the contracts of two fading local TV stars who have asked for hefty raises. Their final decision must be based on factors of budget, image, station history and philosophy, and competitive market strategy.

BACKGROUND

Located in the deep South, Stephenston, U.S.A. has managed to retain its antebellum charm while thriving as a bustling community in today's world of high technology and finance. Presently, the city contains almost 1.7 million inhabitants and is known as an investment banking leader as well as a manufacturing center for the region.

To fill in this general portrait, other, more specific information for Stephenston has been gathered during the last census period. It includes the following:

ADI Market Ranking: 31

ADI TV Households: 636,700

Principle Industries: Printing, Shoes, Paper Products, Hosiery, Food
Products, Glass, Appliances, Boats, Tires, Tourism

Average Household Spendable Income: $20,002

Per Capita Personal Income: 8.8% below the national average

Unemployment Rate: 4.4%

Average Cost of Housing (for a Single Family Dwelling):
 $55,000

Age and Sex of Population: Children 2-17 (30.3%), Women 18-24 (6.3%), Men 18-24
 (6.6%), Women 25-34 (8.7%), Men 25-34 (8.0%), Women 35-49 (9.1%), Men 35-
 49 (8.6%), Women 50-64 (7.7%), Men 50-64 (7.0%), Women 65+ (6.6%), Men
 65+(3.8%)

--Median Age: 29.8 years

--Medical Facilities: 17 hospitals, 2 medical schools, VA hospital,
 speech-hearing center

--Transportation: 1 airport, 2 railroads

--Media Distribution: 5 TV stations, 30 radio stations, 2 newspapers

Among the television stations found in Stephenston, Channel 6, a **network affiliate**, has been an institution since it began broadcasting in 1958. While Channel 6 entered the market somewhat late and faced stiff competition from other stations (both network affiliates), it soon found itself with a loyal audience. . . especially during the daytime. This was due in part to Channel 6's commitment to local programming and dedication to community awareness. Among its premium attractions in this category was a show begun in 1960 called "Good Morning Stephenston" with its cohosts Patsy and Clyde Zaphyr.

The Zaphyrs, for the first 15 years of "GMS", successfully introduced Stephenston to visiting celebrities, up-and-coming music groups from the metropolitan area, recipes, community-interest projects, and consumer information. Their half-hour show usually followed the network morning news program and preceded several mid-morning **syndicated** game shows. In general, "Good Morning Stephenston" was highly-rated, and extremely popular with national advertisers as well as local clients.

Since 1983, however, the Zaphyrs and "GMS" have begun to lose their undisputed hold over the 9:00-9:30 M-F time block (which, incidentally, leads into a very popular game show midmorning block). And, while the program does not have the lowest **share** in the Stephenston

market at present, its slow and continuous decline has captured the attention of Channel 6's station manager, David Nagy. Nagy has been with the station since 1984.

To complicate matters, the Zephyrs' contract will expire next summer, and they each have asked for substantial raises and other benefits, including commercial perks. At present, Patsy and Clyde earn $1,500 each per week for their half-hour show; their new proposal demands a raise of $250 each per week as well as wardrobe benefits, extra vacation weeks, and the opportunity to do commercial spots for extra money. Their total proposed package represents a 30 percent increase from their previous contract.

In their initial discussion regarding the new contract, Patsy and Clyde cited the following arguments for raises in money and benefits:

History

The Zaphyrs contend that their long and prosperous relationship with Channel 6 has been mutually beneficial. For, while Patsy and Clyde have gained in celebrity status, so too has Channel 6 had the benefit of having two strong, stable personalities with which to associate their station. And, since Stephenston is not located in a top ten market, celebrity couples are not found easily

Ratings

The last several rating periods not withstanding, "GMS" (with the Zaphyrs), has captured the largest segment of the viewing audience for the longest, most consistent period of time of any locally-produced program in the area. In addition, the Zaphyrs contend that most of their fan mail is extremely supportive. In fact, if any negativity abounds, it centers around the feeling that their program is too short--that viewers only begin to get comfortable with Patsy and Clyde when the show is over.

Audience

According to ratings reports, the Zaphyrs' audience is mature, educated and economically stable. Any change in "GMS" personalities would threaten the desirable audience "GMS" has worked so hard to obtain throughout the years.

THE PROBLEM

Station Manager Nagy, confronted with both the quarterly ratings reports and the Zaphyrs' demands, sees things somewhat differently. His recent success at Channel 6 has been due to the recognition that today's world is vastly different from the broadcast world in 1960, and that it is important to look at a total picture of viewing trends in "Good Morning Stephenston" rather than to quote individual statistics. According to Nagy, the Zaphyrs are not presenting the total context in their contractual demands. They seem to have overlooked the following:

Advertising Revenue

After computing the average program rating of "Good Morning Stephenston" (Rating=Share of Audience x Households Using Television), the morning talk show was found to measure a 5.9. In other words, 5.9% of Stephenston's 636,700 households were turned to "GMS." Assuming a ratings point variation of ±1 (since one must take into account statistical error), the range of viewer numbers for the show translated into the following:

(low estimate) .049 x 636,700 = 31,198

(mid estimate) .059 x 636,700 = 37,565

(high estimate).069 x 636,700 = 43,932

Further, "GMS" contains space for eight minutes of "nonprogram material" (including station IDs, promos, and PSAs, as well as commercial spots). Assuming a 75 percent sellout of this time to local advertisers (i.e., six minutes), the revenue for each show would generally yield the following profits:

Low (4.9)	Mid (5.9)	High (6.9)
31.198	37.565	43.932
x 4.00	x 4.00	x 4.00
$124.80 per spot	$150.26 per spot	$175.73 per spot

$124.80 per spot	$150.26 per spot	$175.73 per spot
x 6 minutes	x 6 minutes	x 6 minutes
$ 748.80 per show	$ 901.56 per show	$1054.38 per show

(*Note:* These figures include a $4.00 **CPM**--cost per thousand--rate computation for sponsors.)

Multiplied by the five days included in the strip programming, weekly station revenues for "Good Morning Stephenston" range from $3744 to $5270. This yields a present profit margin (after deducting the $3700 for weekly production costs) of $44 to $1570.

Competition

Since l960, Stephenston has acquired an independent as well as a public television station in its market area. Allowing two added sources for audience choice, **ratings** shares are not as large nor as easily attainable for the network affiliates, especially in the morning daypart. Thus, the search for cost-efficient programming that serves as a good lead-in to midmorning fare has become rampant among all local stations. And their choices can range from **first-run syndication** to **off-network re-runs**--a far different perspective in today's world than that found in l960. As Nagy sees it, in fact, his alternatives include the following:

1. The Zaphyrs' Proposed Contract Change and Hour-Long Format. This would cost Channel 6 an added $1040 per show (including production costs); or $5200 per week.

2. A Revised "Good Morning Stephenston." This alternative would maintain the half-hour format and utilize different cohosts. The cost would be approximately $900 per show (including production costs) or $4500 per week. Presently, "GMS" follows a similar budget.

3. Off-Network Re-runs. These range greatly in price, but could include anything from fifties' sitcoms to off-network soaps like "Dallas" or "Dynasty" (for the shows available, please consult the list in the "Syndication at a Glance"--Appendix section).

4. First-Run Syndicated Talk Shows. The prices for syndicated talk shows are negotiated differently for each market. They can be sold on a "cash only" basis or through

barter syndication. Nagy also discovered the average ratings for each in similar markets, and he needs only to compute their potential financial success by multiplying the national rate computation for CPM ($5.00) by the projected ratings in the Stephenston market. Negotiating for Channel 6, Nagy was able to secure the following weekly fees for these programs:

"Donahue"--This show features the fiftyish, white-haired Phil Donahue as host and focuses on controversial political/social issues. Emanating from New York, "Donahue" has a live audience as well as a phone-in segment. This program has averaged a 6.6 rating (±1 ratings point) in similar markets during the same time period, and it seems to be doing quite well on Channel 6's competitor, Network Affiliate A, where it airs from 4:00 PM to 5:00 PM.

•Time: 60 minutes

•Cash + Barter: Distributor receives $9500 per week and 2 of the 15 minutes of nonprogram time per show

DONAHUE: COMPUTATION WORKSHEET

	Low (5.6)		Mid (6.6)		High (7.6)
	636,700		636,700		636,700
	x .056		x .066		x .076
estimated viewers	_____		_____		_____
	x $5.00	(CPM)	x $5.00	(CPM)	x $5.00
	$_____		$_____		$_____
	$_____		$_____		$_____
75% of 13 avail. min.	x 9.75		x 9.75		x 9.75
	$_____		$_____		$_____
5 prog/wk	x 5		x 5		x 5
weekly ad revenue	_____		_____		_____

DONAHUE: COMPUTATION WORKSHEET, continued

weekly ad revenue	$ _____	$ _____	$ _____
syn. price	- 9500	- 9500	- 9500
net profit	$ _____	$ _____	$ _____

"Oprah Winfrey"--Introduced just a few years ago, this show has experienced the most dramatic popularity climb in the history of daytime talk shows. The hostess is a black woman in her mid-thirties who offers an interesting blend of objectivity and emotionalism to her controversial interviews. Live audiences and phone-in segments are also featured. In similar markets, "Oprah" has averaged an 8.0 rating (\pm1 ratings point) during the same time period. Presently, this show is aired from 4:00 PM to 5:00 PM on Network Affiliate B, which has enjoyed a healthy return on its investment.

•Time: 60 minutes

•Cash + Barter: Distributor receives $12000 per week and 2 of the 15 minutes of nonprogram time per show

OPRAH WINFREY: COMPUTATION WORKSHEET

	Low (7.0)		Mid (8.0)		High (9.0)
	636,700		636,700		636,700
	x .070		x .080		x .090
estimated viewers	_____		_____		_____
	x $5.00 (CPM)		x $5.00 (CPM)		x $5.00
	$ _____		$ _____		$ _____
75% of 13 avail. min.	x 9.75		x 9.75		x 9.75
	$ _____		$ _____		$ _____

OPRAH WINFREY: COMPUTATION WORKSHEET, cont.

	$_____	$_____	$_____
5 prog/wk	x 5	x 5	x 5

weekly ad			
revenue	$_____	$_____	$_____
syn. price	- 12000	- 12000	- 12000
net profit	$_____	$_____	$_____

"Hour Magazine"--This show has been popular for over a decade due to the mild, inoffensive manner of its host, Gary Collins. The program is videotaped in front of a live audience and features cooking, exercise, and celebrity segments. It is produced in Los Angeles. In similar markets, "Hour Magazine" has averaged a 6.4 rating (±1 ratings point) during the same time period.

•Time: 60 minutes

•Cash + Barter: Distributor receives $8000 per week and 2 of the 15 minutes of nonprogram time per show

HOUR MAGAZINE: COMPUTATION WORKSHEET

	Low (5.4)		Mid (6.4)		High (7.4)
	636,700		636,700		636,700
	x .054		x .064		x .074
estimated viewers	_____		_____		_____
	x $5.00	(CPM)	x $5.00	(CPM)	x $5.00
	$_____		$_____		$_____
75% of 13 avail. min.	x 9.75		x 9.75		x 9.75
	$_____		$_____		$_____

HOUR MAGAZINE: COMPUTATION WORKSHEET, continued

	$ _____	$ _____	$ _____
5 prog/wk	x ___5___	x ___5___	x ___5___
weekly ad			
revenue	$ _____	$ _____	$ _____
syn. price	- 8000	- 8000	- 8000
net profit	$ _____	$ _____	$ _____

"Sally Jessy Raphael"--This show features segments such as parapsychology, celebrity gossip, and diet tips; it is hosted by a white woman in her fifties. It is generally considered less serious than "Donahue" or "Oprah Winfrey" but commands a large audience of women over forty. In similar markets, "Sally Jessy" has averaged an 5.7 rating (±1 ratings point) during the same time period.

•Time: 30 minutes

•Cash + Barter: Distributor receives $4000 per week and 30 seconds of the 8 minutes of nonprogram time per show

SALLY JESSY RAPHAEL: COMPUTATION WORKSHEET

	Low (4.7)	Mid (5.7)	High (6.7)
	636,700	636,700	636,700
	x .047	x .057	x .067
estimated			
viewers	_____	_____	_____
	x $5.00 (CPM)	x $5.00 (CPM)	x $5.00
	$ _____	$ _____	$ _____

SALLY JESSY RAPHAEL: COMPUTATION WORKSHEET, continued

	$_____	$_____	$_____
75% of 7.5 avail. min.	x 5.5	x 5.5	x 5.5
	$_____	$_____	$_____
5 prog/wk	x 5	x 5	x 5
weekly ad revenue	$_____	$_____	$_____
syn. price	- 4000	- 4000	- 4000
net profit	$_____	$_____	$_____

"Geraldo"--This is a relatively new first-run syndicated show which shows good promise. Similar ADI Markets have shown a 5.0 rating (± 1 point) for airing in this time slot.

•Time: 60 minutes

•Cash + Barter: Distributor receives $6500 per week and 2 of the 15 minutes of nonprogram time per show

GERALDO: COMPUTATION WORKSHEET

	Low (4.0)		Mid (5.0)		High (6.0)
	636,700		636,700		636,700
	x .040		x .050		x .060
estimated viewers	_____		_____		_____
	x $5.00	(CPM)	x $5.00	(CPM)	x $5.00
	$_____		$_____		$_____

GERALDO: COMPUTATION WORKSHEET, continued

	$_____	$_____	$_____
75% of 13 avail. min.	x 9.75	x 9.75	x 9.75
	$_____	$_____	$_____
5 prog/wk			
	x 5	x 5	x 5
weekly ad revenue	$_____	$_____	$_____
syn. price	- 6500	- 6500	- 6500
net profit	$_____	$_____	$_____

(NOTE: "People Are Talking", an hour-long **franchised** talk show, is not listed as an option here since it is already being aired on a competing station.)

Audience

While the Zaphyrs claim that the audience for "GMS" is mature, educated, and economically stable, they have neglected to mention that it is predominantly the same audience that the Zaphyrs attracted over two decades ago. The audience demographic has grown older with each year of "Good Morning Stephenston." The average age of a "GMS" viewer in 1960 was 30; today, the average age is 53. A major question to be asked is whether Channel 6 wants to stay with this demographic or target a show for a younger demographic.

Image

Relatedly, while it is true that Channel 6 has enjoyed a strong station identification with the Zaphyrs for many years, the future of the veteran talk-show hosts is not the only factor one should take into account when evaluating the station's total image. Now, in fact, the Zaphyrs

may need Channel 6 as much as--if not more than--the station needs them. True, they represent Channel 6's early commitment to local programming; but their departure would not necessarily signal the end of a locally-produced talk show. A wise station manager knows when to retire a winning image and when to start anew.

Despite Nagy's differences with Patsy and Clyde Zaphyr about the popularity of "Good Morning Stephenston," his choice of what to do with the 9:00-9:30 AM Monday-through-Friday time slot is not an easy one. This is because there are good arguments for each point of view:

I. There is a tremendous need for Nagy's choice to be consistent with the station's goals and objectives. There is no question that Channel 6 broadcasts its programming to make money; but how much short-term revenue is worth the loss of a station's long-term reputation as a local producer? However, is today's audience more apt to forego a show with "local color" and opt instead for a slicker, more expensive national product? Either way, Nagy must balance the value of his station's community identity with the advertising revenue potential of syndicated programming.

2. Nagy also must consider the temporary nature of any show's popularity over a given span of time. Drastically changing a programming daypart, Nagy may increase his ratings quickly. He's also vulnerable to an equally rapid drop within a few weeks. Speculative buying, in short, may prove to be extremely rewarding; it may also prove disastrous in long-term revenue and station identity.

3. "Good Morning Stephenston" is not as highly-rated as it has been in the past, but it's not in any serious ratings jeopardy. Is it wise to "fix" something if it "hasn't broken?"

4. The Zaphyrs may be overstating their case a bit, but they are correct when they point out that they are Stephenston's only celebrity couple. Might Channel 6 lose a valued commodity if it doesn't honor their new contractual demands?

5. Each programming option (local production, first-run syndication or off-network re-runs) has both advantages and disadvantages. For example, retaining "Good Morning Stephenston" with the Zaphyrs' new demands would cost Channel 6 more than it has in the past. Unfortunately, there's a possibility that advertising revenues will not increase with the cost

percentage of the show; in fact, they may decline. Replacing the Zaphyrs with new co-hosts, on the other hand, may cost less; but it will also be riskier.

The **license fees** of a syndicated talk show can be more expensive, but the shows are usually proven successes (like "Oprah Winfrey"). On the other hand, it is important to remember that first-run syndications can be speculative buys--they may do well in *similar* markets, but that doesn't necessarily mean they will do well in Stephenston. Nagy must also take into account the fact that "Oprah" and "Donahue" are already being shown at different times on different channels--their marketability may not be as high as projected by the figures.

Finally, most older syndicated shows are safer and much less expensive than either first-run syndications or local productions. However, they also yield lower revenues than the other two programming types and provide no distinct image for the station.

In summary, Nagy's programming choice is not an easy one, although there are many possibilities. They range from honoring the Zaphyrs' contract proposal completely to tossing Patsy and Clyde away and beginning anew. Several options, of course, would fall in between these two diametrically-opposed approaches.

SUGGESTED ASSIGNMENT FOR DISCUSSION

David Nagy has asked his program director to call a general staff meeting to discuss the "Good Morning Stephenston" situation. As he sees it, there are several possible scenarios. Included among them are these four: 1) "Good Morning Stephenston" could change according to the Zaphyrs' wishes; 2) "GMS" could remain as is with new cohosts; 3) "Good Morning Stephenston" could be replaced with a 30- or 60-minute first-run syndicated talk show; or 4) "GMS" could be replaced with one or two off-network "syndie" programs.

Students will be assigned to the following small groups to study the ramifications of each scenario from various points of view:

1. Local sales
2. National sales
3. Promotion
4. Accounting/finance
5. Audience research
6. Public relations

Once the small groups have researched the case study by reading current articles from newspapers, magazines and trade journals, a representative from each subject area should present the group's perspective on each scenario. They also should present their respective arguments for the final recommendation.

WRITTEN ASSIGNMENT

As David Nagy's Program Director, you are asked to consider all the perspectives presented in previous class discussions. Based on this data, you should be able to:

1. Give Mr. Nagy a recommendation about the contractual fates of Patsy and Clyde Zaphyr

2. Provide a programming proposal to support your recommendation about "Good Morning Stephenston"

Your recommendation should not exceed seven pages. Be sure to define clearly your suggested programming approach, providing specific proposals as well as your reasons for proposing them.

To help you make these decisions, here is the typical weekday morning program log for Stephenston. The numbers beside each show represent audience ratings averages as computed from the last quarterly ratings report:

MORNING

	7:00	7:30	8:00	8:30	9:00	9:30	10:00	10:30	11:00	11:30	12:00
CH. 6	Network Morning Show (6.7)				GMS (5.9)		Syn./Net. Game Shows (6.6)				News (5.0)
NET AFF. A	Network Morning Show (5.9)				People are Talking (6.2)		Off-net. Sitcom Re-runs (5.8)				News (4.9)
NET AFF. B	Network Morning Show (6.5)				Off-net. Sitcom Re-runs (5.7)		Syn./Net. Game Shows (6.2)				Magnum P.I. (4.9)
PUBLIC TV	Off-air		Sesame St. (2.1)		Electric Co. (1.5)		Educational TV Programming (NR)				
INDEPEND.	Cartoons (3.6)				Off-net. Drama Re-runs (4.7)						Movie (4.0)
A&E	TV's Gold Age (.7)		Footsteps (.6)		Previn (.4)		Movie (2.2)				
BRV	Off-air										
DIS	Pooh Corner (.5)		Mickey Mouse (.8)		Schooner (1.1)		Dumbo (2.6)		Walt Disney Presents (2.4)		
ESPN	Nation's Business Today (.4)		Sportcenter (2)		Windsurfing (0)				Golf (.8)		
HBO	Movie (1.8)						Movie (2.1)				
MAX	Movie (1.2)				Movie (1.9)				Movie (.8)		
MC	Movie (.9)						Movie (1.6)				
SHO	Movie (1.3)						Movie (1.8)				
TBS	Cartoons (2.3)		Off-net. Sitcoms (2.4)				Movie (1.4)				TBA
USA	Cartoons (1.7)						Off-net. Dramas (2.5)				
WGN	Off-net. Sitcoms (2.1)						Off-net. Dramas (2.3)				
WOR	Cartoons (.4)						Movie (1.2)				

Figure 3.18. A typical weekday morning program log for Stephenston. The numbers beside each show represent audience ratings averages based on the last quarterly ratings report.

Case Study 8: Winning the Ratings War with Local News

Here, students must consider the relationship between networks and their affiliates: when a local image must take precedence over network concerns, and when local programming becomes a primary consideration to the program director or general manager. One of these times occurs during a ratings sweep period, when local news ratings may determine future ad rates in the next few months. As program directors, students will strategize to win this ratings war with local news.

BACKGROUND

Network-**affiliated** stations comprise the vast majority of television outlets in America today. Whether **independently-** or **group-owned** , these stations exert a great amount of influence on our country's notion of news, information and entertainment.

Affiliates generally depend on their networks for 70-75 percent of their total program fare, including:

1. three hours of **prime time** each night Monday through Saturday
2. four hours of prime time Sunday nights
3. a half-hour of network news each night
4. at least two hours of early morning programming five days a week
5. weekday midmorning and early afternoon fare
6. weekend sports

The local affiliate has the option to refuse to air a network program but only does so for a few specific reasons. They include the following: 1) the show is considered objectionable for its broadcast area; 2) it shows low local ratings; or 3) the affiliate can better serve its public (or

make more money) by airing something else. However, as stated earlier, it is the exception rather than the rule that local affiliates turn down a network program.

Obviously, being a network affiliate has many clear-cut advantages in today's television world. Affiliates can provide popular, celebrity-laden, technically slick programming to their viewers. They also have many of their promotional supplies provided, so they can promote many of their shows with very little expense. Network affiliates also enjoy reduced rates on supplies, equipment, and **syndicated** programming, because they are purchased on a large scale. Most stations, if given the opportunity, are only too happy to accept a network affiliateship.

However, despite all the advantages, affiliates also can experience problems in being associated with a network. First, if the network is running a poor third to the other two, an affiliate is often strapped with unpopular programming over which it has no control. Second, even when network programs are popular, the affiliate must face the challenge of maintaining a separate identity within the network structure.

When surveying the amount of network time that occupies most affiliates' schedules, the two-fold task of maintaining a strong local image while being loyal to network concerns can be a constant struggle. However, one way of accomplishing both objectives is to establish a strong reputation for local news. It is little wonder, then, that the ratings wars in most TV markets are concentrated on the presentation of local news--format, time slot, celebrities, and image.

THE PROBLEM

Ellisburg is a **large-market** metropolitan area located in the Midwest. It has six television stations within its broadcast range--three group-owned network affiliates, two independents and one public TV station. Recently, the quarterly ratings report was issued for Ellisburg. Here is a brief summary of each affiliate's news format, as well as its popularity within the community.

Channel 4

Channel 4 is an NBC affiliate, owned by a group of local businesspeople (Ellisburg Broadcasters, Inc). During the week, it broadcasts its news in four segments: 6:30-7:30 AM; 5:00-6:00 PM; 6:00-6:30 PM; and 11:00-11:30 PM. The 6:00 PM newscast precedes NBC's nightly network news. Channel 4's primary news team works at 6:00 and 11:00 PM and is comprised of two news coanchors who happen to be married to each other (a middle-aged white man and white

woman); a thirtyish, white weatherman; a black female consumer reporter in her late twenties; and a 32-year-old Hispanic male sports anchor. The married news anchors have been employed by Channel 4 for almost ten years--and because of this, they are strongly identified with that station. The weatherman, consumer reporter, and sports anchor, however, have come to Ellisberg much more recently. Each has been around for less than two years.

Lately, Channel 4 (though showing more strength than in past ratings periods) has remained firmly entrenched in third place with a 13 rating, 26 share for its 6:00 PM newscast and a 12/24 for the 11 o'clock wrap-up.

Channel 8

Channel 8 is Ellisburg's CBS affiliate, owned by Field Communications. Monday through Friday, it broadcasts its local news at 6:30-7:00 AM, noon-12:30 PM, 6:00-7:00 PM, and 11:00-11:30 PM. "The CBS Evening News" follows the 6:00-7:00 PM slot. Channel 8's primary news team works the 6:00 and 11:00 PM shifts, and is comprised of two news coanchors (a black woman in her mid- thirties and a white man in his late forties); a fortyish, white weatherman; a 25-year-old Asian female consumer reporter; a fortyish black female medical correspondent; and a white male sports anchor in his late thirties. Channel 8 first gained national recognition for hiring a black woman as primary news anchor in the early seventies. Since that time, the station has been known as a liberal, professionally-run news organization that shows a special interest in community affairs.

The most recent ratings reports show Channel 8 in second place at 6:00 PM with a 14 rating, 28 share. However, Channel 8 news has now been deemed a clear leader at 11:00 PM with a 16/34.

Channel 10

Channel 10 is the ABC affiliate, owned by Capital Cities Broadcasting, Inc. It has enjoyed consistently noncontested top ratings in both the 6:00 and 11:00 PM newscasts for over ten years. However, Channel 8 has recently mounted an increasingly strong challenge for top spot, and, indeed, has overtaken Channel 10 in the latest ratings report for the 11:00 newscast with a 16 rating, 34 share. Channel 10 broadcasts its local news thrice daily--from 5:00-6:00 AM, 6:00-7:00 PM, and 11:00-11:30 PM. ABC's nightly newscast follows the station's evening slot. Channel 10's 6:00 and 11:00 PM reports feature a white male news anchor in his late fifties, a

fiftyish white weatherman, a 43-year-old white male sports anchor, and a white female entertainment reporter in her early fifties. Channel 10 has kept this team for over a decade, and changed little of its basic news format. The most recent addition to the Channel 10 newscast has been technological, not personal: It now has become the first station in the area to have a satellite news operation.

The latest quarterly ratings report showed Channel 10 still ranked ahead of the other two affiliates in its 6:00 PM news, posting a 15 rating, 30 share. However, at 11:00 PM, it has slipped to a 14/29.

Each of these affiliates has both strengths and weaknesses from which to operate. They include (but are not limited to) the following:

1. the overall ratings' strength of each affiliate's network
2. the composition of the primary news team
3. the time slots of local news throughout the day
4. the amount of programming time devoted to local news
5. local station image
6. network image
7. past local news ratings

Meanwhile, the strength, type, and amount of promotion devoted to local news are important elements for consideration. According to most audience research surveys, news promotion campaigns usually contain three major "selling" points: 1) the "professionalism" of the station's news team; 2) its "state of the art" technological equipment; and 3) the warm, personal natures of the news anchors. Further, promotional ad placement is just as important as its content. A station that uses some of its available nonprogram time during a popular show might actually end up making more money in the long run than it would by simply *selling* the specific air time directly to advertisers.

Thus, local news content, placement and promotion involve important programming decisions by the general manager, the news director, the program manager, and the creative services director.

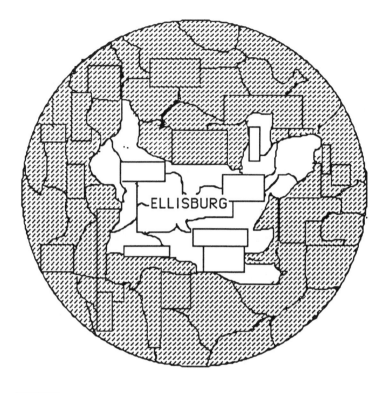

☐ Denotes Ellisburg's metropolitan area

▨ Denotes the remaining coverage area

Figure 3.19. Coverage area for the Ellisberg ADI market.

SUGGESTED ASSIGNMENT FOR DISCUSSION

The class should be divided into three groups; each group will study a specific network affiliate in their community. Having researched these affiliates, members of the class will share their impressions about the news operations at each affiliate. Included in this discussion should be the following:

1. an analysis of the overall ratings strength of the network associated with the affiliate

2. a "personality" profile of the station's news team

3. a brief commentary about the station's news times and content

4. a description of the station's overall image based on promotional ads, community activities and network affiliation (be sure to include *specific* TV and radio spots, print ads and community activities to bolster your discussion).

WRITTEN ASSIGNMENT

Based on the suggested discussion assignment (indicated above) and the brief profiles of Ellisburg's network-affiliated TV stations, choose one of the three fictional affiliates and analyze its strengths and weaknesses. Afterward, you should present specific suggestions for obtaining (or maintaining) the highest ratings possible for this station. Remember that the key to success in the assignment involves both programming *and* promotion.

CASE STUDY 8: WINNING THE RATINGS WAR WITH LOCAL NEWS

NAME: _____ DATE: _____

COURSE: _____ PROFESSOR: _____

TV Station: _____ Affiliated with _____ (network)

(check one) ____ Independently-owned _____ Group-owned

Station Strengths

Specific aspects of consideration will be mentioned here. However, if you do not see one or more of them as "strengths," simply leave the space(s) blank.

1. Overall ratings' strength of the affiliate's network:

2. Demographic composition of the primary news team:

3. The time slots for local news programming throughout the day:

4. The amount of programming time devoted to local news:

5. The ratings' strength of the affiliate's network news programs:

Station Weaknesses

Specific aspects of consideration will be mentioned here. However, if you do not see one or more of them as "weaknesses," simply leave the space(s) blank.

1. Overall ratings' strength of the affiliate's network:

2. Demographic composition of the primary news team:

3. The time slots for local news programming throughout the day:

4. The amount of programming time devoted to local news:

5. The ratings' strength of the affiliate's network news programs:

Suggested Changes

Rationale for Changes

SUGGESTED PROMOTIONAL CAMPAIGN

Be specific, including ideas for TV and radio promos, print ads, outdoor advertising, and community relations.

Overall Campaign

Suggested TV Promos

Suggested Radio Promos

Suggested Print Ads

Suggested Outdoor Advertising

Suggested Community Activities

Network Television Case Studies

Case Study 9: Proposing a New Series for Public Television

This study places students in the role of noncommercial station producers who want to "pitch" a series to the CPB, SPC, or a potential corporate underwriter. It allows instructors to explain the process of programming selection in public broadcasting and creates an environment to compare the elements of program consideration in commercial TV versus noncommercial television.

BACKGROUND

Unlike the broadcast systems of most industrialized countries, **public television** in the United States has never really experienced a central place in governmental programming policy. Rather, for many years, **"noncommercial"** television was synonymous with "classroom" or "educationally-produced" media. Accordingly, little if any national funding was granted for such ventures. It was felt that noncommercial outlets would have only a small impact on the overall cultural awareness in this country; thus they were considered "low priorities" for governmental support.

However, the complexion of noncommercial TV changed drastically after 1967, when the Carnegie Commission laid the foundations for the Corporation for Public Broadcasting (CPB). During this time, a new concept called "public television" emerged, in which noncommercial broadcasting was seen as culturally valuable as well as educationally beneficial. The government allotted funding for the CPB, its national distribution outlet (PBS), and all **affiliated** stations, to help public TV become technically and aesthetically competitive with commercial broadcasting. The Congress also suggested that the CPB, PBS and their affiliates seek funding from other sources, including corporate underwriting and viewer subscriptions. The U.S. government thus developed a federally supported network without violating their original premise that broadcasting should be **competitive** and privately-owned.

Today, public television stations, much like their commercial counterparts, obtain their broadcast programming from four different sources: 1) network distribution (**PBS**); 2) major independent producers and distribution centers (such as The Children's Television Workshop, Family Communications, Inc., and Agency for Instructional Television); 3) regional networks (like Eastern Educational Network, Southern Educational Communications Association, Central Educational Network, and Pacific Mountain Network); and 4) local production. In general, however, network distribution services about 80 percent of a station's programming needs.

The network distribution source for public television is the Public Broadcasting Service. PBS produces no programming of its own; rather, it funds several productions from affiliated TV stations (through the Station Program Cooperative) and buys many shows from American and foreign (notably British and Canadian) independent producers.

The Public Broadcasting Service divides its programming into three sections:

1. PTV-1, which oversees prime-time programs for general audiences

2 PTV-2, which is responsible for "special interest" shows (especially those intended for women and minority groups)

3. PTV-3, which produces educational and instructional programming for children and adults.

To date, much PTV-1 programming is still being provided by foreign suppliers. However, American independent producers are now being encouraged, more than ever, to submit programming ideas for consideration.

As for PTV-2 and PTV-3 programming, most shows produced for PBS distribution are national, emanating from four main locations: WGBH-TV, Boston; WNET-TV, New York; WETA-TV, Washington; and KCET-TV, Los Angeles. The remainder of domestically-produced network programming slots generally is awarded to individual stations after their proposals have been approved by the Station Program Cooperative (SPC) at the annual PBS Program Fair.

The SPC was formed in 1974 as a forum for competitive program exchanges. All PBS-affiliated stations are members of this cooperative and have the power and funding from the CPB or PBS to approve specific programs for their stations. Generally, the annual Program Fair is conducted as follows:

1. All interested producers submit formal program proposals to PBS (including booklets, demo tapes, press kits, etc.) and are assigned to designated booths at the Fair.

2. The prospective buyers--station owners--survey the booths by means of a catalogue. This catalogue is distributed to all Fair attendees at the outset so that they may choose how best to spend their CPB stipend.

3. During the first few days (after the SPC station owners have had a chance to survey each booth), "elimination" rounds are conducted to determine the final list of proposed programs for national distribution.

4. Each SPC member votes on this final list, indicating whether or not he/she will use the station's CPB budget allotment to air the show(s).

If enough money is allotted from the SPC, the proposed program will be aired in all markets where station funding has been given. If the proposed program fails SPC support, the producer has the option to seek monies from private corporations, and/or resubmit for network consideration the following year.

After reviewing the methods of production and distribution through PBS, it is safe to say that noncommercial television has indeed cultivated valuable programming resources--including foreign imports, independent domestic productions, and SPC-supported ventures--for its quality **alternative** network.

THE PROBLEM

Despite public TV's rapid growth for two decades, however, its future is once again being called into question. As John Weisman has noted in *TV Guide,*

> It is a billion-dollar-a-year enterprise that seems permanently in
> danger of financial collapse. It employs almost 10,000 people at

more than 300 stations nationwide, but seldom gets more than
three per cent of the television audience.[*]

The reasons for concern are several. They include the following:

1. Federal funding has decreased substantially during the same period when even more
money is needed to nurture ongoing quality productions.

2. While many viewers "support" public television by watching it, less than 10 percent of
these people are monetary contributors. Also, only a small percentage of the total number of
American corporations consistently underwrite PBS shows.

3. Public television station owners are now experiencing increased bidding competition for
similar shows from cable networks, commercial **independents**, and **superstations**. In fact, one
could say that commercial television has discovered the popularity of cultural programming
through public TV.

These governmental, economic, and programmatic difficulties are not likely to dissipate in
the near future. Thus, it is important to understand clearly the strengths and weaknesses of
public television in the United States, so that it can continue to thrive despite its growing
competition.

SUGGESTED ASSIGNMENT FOR DISCUSSION

Identify the cable networks, independents, and superstations which serve as direct
competition for the PBS station in your community. Which shows do they air? Why do you think
they program these shows--for commercial success, image enhancement, or a combination of the
two? How can PBS use its past reputation and fund-raising talents to add a more competitive
edge to its bidding power?

WRITTEN ASSIGNMENT

Analyze the programming schedule of your local public television station. Identify which
programs are locally-produced, which are regional, and which are national. Next, list the

[*]John Weisman, "Public TV in Crisis--Can It Survive?" *TV Guide* (August 1, 1987), pp. 2-3.

sponsor(s) for each show (corporate underwriting, SPC, etc.). Implementing this information, where would you concentrate most of your efforts when proposing a new program? Why?

To aid you in your analysis, please use the forms provided on the last several pages of this case study.

DAY	PROGRAM TITLE*	SOURCE**	SPONSOR(S)
MONDAY			

*Many programs on public television are repeated several times each day (and week). You need only identify the show once to record its needed information.

**"Source" is defined here as "local," "regional," or "network."

<u>DAY</u>	<u>PROGRAM TITLE</u>＊	<u>SOURCE</u>＊＊	<u>SPONSOR(S)</u>
MONDAY	_____	_____	_____
	_____	_____	_____
	_____	_____	_____
	_____	_____	_____
	_____	_____	_____
	_____	_____	_____
	_____	_____	_____
	_____	_____	_____
	_____	_____	_____

＊Many programs on public television are repeated several times each day (and week). You need only identify the show once to record its needed information.

＊＊"Source" is defined here as "local," "regional," or "network."

DAY	PROGRAM TITLE*	SOURCE**	SPONSOR(S)
TUESDAY	_____	_____	_____
	_____	_____	_____
	_____	_____	_____
	_____	_____	_____
	_____	_____	_____
	_____	_____	_____
	_____	_____	_____
	_____	_____	_____
	_____	_____	_____

*Many programs on public television are repeated several times each day (and week). You need only identify the show once to record its needed information.

**"Source" is defined here as "local," "regional," or "network."

DAY	PROGRAM TITLE*	SOURCE**	SPONSOR(S)
TUESDAY			

*Many programs on public television are repeated several times each day (and week). You need only identify the show once to record its needed information.

**"Source" is defined here as "local," "regional," or "network."

DAY	PROGRAM TITLE*	SOURCE**	SPONSOR(S)
WEDNESDAY	_____		

*Many programs on public television are repeated several times each day (and week). You need only identify the show once to record its needed information.

**"Source" is defined here as "local," "regional," or "network."

DAY	PROGRAM TITLE*	SOURCE**	SPONSOR(S)
WEDNESDAY			

*Many programs on public television are repeated several times each day (and week). You need only identify the show once to record its needed information.

**"Source" is defined here as "local," "regional," or "network."

DAY	PROGRAM TITLE*	SOURCE**	SPONSOR(S)
THURSDAY			

*Many programs on public television are repeated several times each day (and week). You need only identify the show once to record its needed information.

**"Source" is defined here as "local," "regional," or "network."

DAY	PROGRAM TITLE*	SOURCE**	SPONSOR(S)
THURSDAY	_____		

*Many programs on public television are repeated several times each day (and week). You need only identify the show once to record its needed information.

**"Source" is defined here as "local," "regional," or "network."

DAY	PROGRAM TITLE*	SOURCE**	SPONSOR(S)
FRIDAY	_____		

*Many programs on public television are repeated several times each day (and week). You need only identify the show once to record its needed information.

**"Source" is defined here as "local," "regional," or "network."

DAY	PROGRAM TITLE*	SOURCE**	SPONSOR(S)
FRIDAY			

*Many programs on public television are repeated several times each day (and week). You need only identify the show once to record its needed information.

**"Source" is defined here as "local," "regional," or "network."

DAY	PROGRAM TITLE*	SOURCE**	SPONSOR(S)
SATURDAY			

*Many programs on public television are repeated several times each day (and week). You need only identify the show once to record its needed information.

**"Source" is defined here as "local," "regional," or "network."

DAY	PROGRAM TITLE*	SOURCE**	SPONSOR(S)
SATURDAY	_____		

*Many programs on public television are repeated several times each day (and week). You need only identify the show once to record its needed information.

**"Source" is defined here as "local," "regional," or "network."

DAY	PROGRAM TITLE*	SOURCE**	SPONSOR(S)
SUNDAY			

*Many programs on public television are repeated several times each day (and week). You need only identify the show once to record its needed information.

**"Source" is defined here as "local," "regional," or "network."

DAY	PROGRAM TITLE*	SOURCE**	SPONSOR(S)
SUNDAY	_____	_____	_____
	_____	_____	_____
	_____	_____	_____
	_____	_____	_____
	_____	_____	_____
	_____	_____	_____
	_____	_____	_____
	_____	_____	_____
	_____	_____	_____

*Many programs on public television are repeated several times each day (and week). You need only identify the show once to record its needed information.

**"Source" is defined here as "local," "regional," or "network."

Case Study 10: Counterprogramming on Superbowl Sunday

Many times a blockbuster event is scheduled on one network, leaving everyone else with the dilemma of what to air during the same timeslot. What are a network programmer's alternatives, for example, if the all-powerful Superbowl is broadcast on a rival network? Students are asked to consider the possibilities of power programming, counter-programming, alternative shows, or other strategies that are discussed in the case study and in class.

BACKGROUND

Historically, "Superbowl Sunday" has been a ratings **blockbuster** for any network that buys the rights to the "big game." At least six Superbowls can be found on the list of TV's top twenty highest ratings for all time, and this trend in ratings popularity seems to be growing rather than declining.

Obviously, a sure ratings winner means easy money for the lucky network involved, despite the hefty license fee it must pay. So, not so surprisingly, "Superbowl Sunday" has won many revenue contests as well as ratings battles. Believe it or not, for the first time in 1985, ABC passed the million-dollar mark in setting their price for one minute of national advertising in the game. . . and sold *all* of the time. The ad rates have continued to rise since then, and industry experts see no "rate ceiling" in the near future. In short, the high costs of purchasing the rights to "Superbowl Sunday" have been well worth the money, and everyone is more than happy to consider using much of their network budgets to bid for the rights to the game.

Ironically, most of the recent Superbowl spectacles have been scoring blowouts; however, that statistic doesn't seem to reflect in the ratings.

In 1985, the network schedule on Super Sunday looked like this:[*]

<u>TIME</u>	<u>ABC</u>	<u>CBS</u>	<u>NBC</u>
6:00 PM	SUPERBOWL XIX	CBS NEWS	LOCAL NEWS
6:30 PM		LOCAL NEWS	NBC NEWS
7:00 PM		60 MINUTES	SILVER SPOONS (R)
7:30 PM		60 MINUTES, (cont.)	PUNKY BREWSTER(R)
8:00 PM		MURDER, SHE WROTE(R)	KNIGHT RIDER (R)
8:30 PM		MURDER, SHE WROTE, cont.	KNIGHT RIDER cont.
9:00 PM		CRAZY LIKE A FOX (premiere)	MOVIE (1983 made-for-TV repeat)
9:30 PM	SUPERBOWL XIX POSTGAME	CRAZY LIKE A FOX, cont.	MOVIE, cont.
10:00 PM	MACGRUDER AND LOUD (premiere)	TRAPPER JOHN, M.D.	MOVIE, cont.
10:30 PM	MACGRUDER AND LOUD, cont.	TRAPPER JOHN, cont.	MOVIE, cont.
11:00 PM	LOCAL NEWS	LOCAL NEWS	LOCAL NEWS

[*]*TV Guide* (January 19, 1985), pp. A56-A68.

The subsequent ratings were as follows:†

"Superbowl XIX"--46.4 rating; 63 share

"Superbowl XIX Postgame Show"--30.6 rating; 42 share

"MacGruder and Loud"--22.8 rating; 38 share

"60 Minutes"--rating not listed; 19 share

"Murder, She Wrote"--rating not listed; 19 share

"Crazy Like a Fox"--18.4 rating; 26 share

"Trapper John, M.D."--17.3 rating; 28 share

"Silver Spoons," "Punky Brewster," "Knight Rider," and "NBC Movie"--ratings and shares not indicated (*Variety* simply stated that these shows all hit season lows)

THE PROBLEM

When one network is scheduled to broadcast a sure-fire blockbuster hit, the other two networks have several reactive programming strategies from which to choose:

1. **power programming**--pitting one strong show against another, thereby attempting to divide the very large potential audience

2. **counter-programming**--assuming that the competing show will do well, offering a sharply different type of program and thus appealing to a smaller (but less risky) audience potential

3. **long-form**--providing a special episode or extending the length of a popular program to capture its usual viewing audience

4. **front-loading**--programming the regular fare, but supplementing it with high-power celebrities, or unusually strong or controversial topics

5. accepting defeat for the time block--knowing that the competition will probably win anyway, the network saves its money and power programming for another, more advantageous time

†"Super Sunday Powers ABC-TV to First Weekly Ratings Win; Looks Like its Now or Never," *Variety* (January 23, 1985), pp. 51 and 88.

SUGGESTED ASSIGNMENT FOR DISCUSSION

Look through the *TV Guide* for other examples of blockbuster programming--most notably during ratings sweep weeks, awards shows, and playoff games in championship sporting events. How did the competing networks strategize against the blockbuster show? Can you make any generalizations about how to handle power programming?

WRITTEN ASSIGNMENT

For purposes of this assignment, assume the following:

1. CBS will broadcast the next Superbowl game

2. you are the Programming Executive for one of the other competing networks

Based on your knowledge of programming strategies as well as the 1985 example mentioned earlier and your research of the last three years of "Super Sunday" programming, write a short essay detailing your proposed TV schedule for next year's "Super Sunday." Be specific in describing your programming choices, and, as always, be sure to provide a strong rationale for each of your selections.

CASE STUDY 10: COUNTERPROGRAMMING ON SUPERBOWL SUNDAY

NAME _____ DATE _____

COURSE _____ PROFESSOR _____

SUPERBOWL SUNDAY (YEAR: _____)

	6:00	6:30	7:00	7:30	8:00	8:30	9:00	9:30	10:00	10:30	11:00	11:30
CBS												
NBC												
ABC												

SUPERBOWL SUNDAY (YEAR: _____)

	6:00	6:30	7:00	7:30	8:00	8:30	9:00	9:30	10:00	10:30	11:00	11:30
CBS												
NBC												
ABC												

SUPERBOWL SUNDAY (YEAR: _____)

	6:00	6:30	7:00	7:30	8:00	8:30	9:00	9:30	10:00	10:30	11:00	11:30
CBS												
NBC												
ABC												

PROPOSED PROGRAMMING STRATEGY FOR SUPER SUNDAY

(YEAR: _____)

	6:00	6:30	7:00	7:30	8:00	8:30	9:00	9:30	10:00	10:30	11:00	11:30
CBS	SUPERBOWL GAME							POST-GAME SHOW (approx)	NETWORK PREMIERE OF A NEW SERIES		LOCAL PROGRAMMING	
NBC												
ABC												

RATIONALE:

Case Study 11: The Network Programmer

Students learn what mini-series and made-for-TV movies are all about when they read a book from the current best sellers list and try to decide whether the material is suitable for ratings sweep programming.

BACKGROUND

Four times annually--during the months of February, May, July, and November--both cable and broadcast networks consult with special ratings services that summarize their general performance throughout the year, and subsequently rank them as #1, #2, #3, etc., in overall standing. These quarterly reports have come to be known as "sweep periods." It is during these weeks that networks pull out all the stops and provide every type of **blockbuster** programming available to capture invaluable ratings points. Among the strategies used in sweep weeks are:

1. TV specials
2. TV-movie premieres
3. feature films broadcast on television for the first time
4. two- or three-part episodes of regular shows
5. **long-form** programs
6. **stunting**
7. **front-loading**
8. **mini-series**

The mini-series has become most popular of these formats and is most often associated with ratings sweep periods. As a result, network executives are constantly looking for written material that can be adapted successfully to the television screen.

THE PROBLEM

Unfortunately, the mini-series format does not necessarily guarantee a ratings victory nor financial reward. For every success story (such as "Rich Man, Poor Man," "Roots," or "The Thorn Birds"), there are several colossal failures--those mini-stories (like "The Winds of War" or "Princess Daisy") whose production costs have far outweighed their ultimate ratings' worth.

The successful programming executive, then, must make several key judgments as to:

1. the popularity of a novel in print versus its potential on screen
2. how well the novel might be adapted
3. the proper casting and set locations
4. cost effectiveness
5. the most optimal dates and times for airing
6. the total number of hours committed to the drama
7. the most effective promotion

If intelligent decisions have been made at the outset of the project, chances are that the network will win large audiences during the sweeps weeks. It is important to note, however, that any major investment for a heavy ratings period is extremely risky.

SUGGESTED ASSIGNMENT FOR DISCUSSION

Looming powerful in the first three decades of network television programming, the "big three"--ABC, CBS, and NBC--rarely considered any other TV source to be as important as they were. However, in the past several years, cable television has added a new dimension to the networks' competitive concerns. Discuss how cable has affected network television in the following areas:

1. programming sources
2. promotional sources
3. budgeting
4. audience demographics
5. ratings
6. shares

7. attractiveness to advertisers

8. attractiveness to affiliates/potential affiliates

9. union power, from such sources as writing guilds, director's
guilds, etc.

WRITTEN ASSIGNMENT

Choose a novel to read from the *New York Times* best seller list (or from another equally credible source). Remember that this book should be one that has not already been adapted for television or film.

Your job, as the network programmer (either in cable or broadcasting), is to make the following decision: Should this novel be accepted for network programming?

If so:

--Who should be cast as major characters (assuming their availability)?

--Should the story be produced as a televised play, made-for-television movie, mini-series, or series?

--How would you modify the novel for your choice of production (see above)?

--When should the program be aired?

--What type of publicity campaign should be launched to promote the program(s)? GIVE SPECIFIC SUGGESTIONS.

If not:

--Why not?

--What alternative would you suggest that would serve as better competition against the other networks?

--Why is this alternative more beneficial to the program than the assigned novel?

--What would your promotional campaign be for your alternative plan? GIVE SPECIFIC SUGGESTIONS.

This assignment should not exceed ten typewritten pages, and should reflect past lectures, case studies and readings. BE CREATIVE AND PERSUASIVE IN YOUR ARGUMENTS--the true marks of good programming execs--sloppy presentations will hurt your case.

Appendixes

This section includes samples of specific resources that can be found in trade magazines like *Variety* and *Broadcasting*. Each year, you should be able to locate special issues that carry information such as annual syndication availabilities, current network schedules, top group ownerships, current radio format ratings/rankings, and yearly TV programming prices. Using this data, you will be better able to analyze the case studies. To illustrate, here are some listings for 1987-1988:

1. Appendix A: Top Twenty Group Owners*

2. Appendix B: Fall Arbitron Report*

3. Appendix C: 1987-1988 Network Primetime Season at a Glance†

4. Appendix D: Current Syndication at a Glance†

* Reprinted by permission from *Broadcasting* magazine.
† Reprinted by permission from *Variety*.

Appendix A: Top Twenty Group Owners

1. Capital Cities/ABC
(24.43%)

Ch. 7 WABC-TV New York (1) 7.74%
Ch. 7 KABC-TV Los Angeles (2) 5.25%
Ch. 7 WLS-TV Chicago (3) 3.47%
Ch. 6 WPVI-TV Philadelphia (4) 2.98%
Ch. 7 KGO-TV San Francisco (5) 2.41%
Ch. 13 KTRK-TV Houston (10) 1.65%
Ch. 11 WTVD(TV) Durham, N.C. (35) .70%
Ch. 30 KFSN-TV Fresno, Calif. (63) .23%.

2. NBC
(22.36%)

Ch. 4 WNBC-TV New York (1) 7.74%
Ch. 4 KNBC-TV Los Angeles (2) 5.25%
Ch. 5 WMAQ-TV Chicago (3) 3.47%
Ch. 4 WRC-TV Washington (9) 1.79%
Ch. 3 WKYC-TV Cleveland (11) 1.59%
Ch. 4 WTVJ(TV) Miami (16) 1.37%
Ch. 4 KCNC-TV Denver (19) 1.15%

3. CBS Broadcast Group.
(19.44%)

Ch. 2 WCBS-TV New York (1) 7.74%
Ch. 2 KCBS-TV Los Angeles (2) 5.25%
Ch. 2 WBBM-TV Chicago (3) 3.47%
Ch. 10 WCAU-TV Philadelphia (4) 2.98%

4. Fox Television Stations Inc.
(19.425%)

Ch. 5 WNYW(TV) New York (1) 7.74%
Ch. 11 KTTV(TV) Los Angeles (2) 5.25%
Ch. 32 WFLD(TV) Chicago (3) 1.735%
Ch. 25 WFXT(TV) Boston (6) 1.155%
Ch. 33 KDAF(TV) Dallas (8) .93%
Ch. 5 WTTG(TV) Washington (9) 1.79%
Ch. 26 KRIV(TV) Houston (10) .825%

5. Tribune Broadcasting Co.
(18.69%)

Ch. 11 WPIX(TV) New York (1) 7.74%
Ch. 5 KTLA(TV) Los Angeles (2) 5.25%
Ch. 9 WGN-TV Chicago (3) 3.47%
Ch. 46 WGNX(TV) Atlanta (12) .715%
Ch. 2 KWGN(TV) Denver (19) 1.15%
Ch. 26 WGNO-TV New Orleans (34) .365%

6. Home Shopping Network
(14.63%)

Ch. 68 WHSE(TV) Newark (1) 3.87%
Ch. 67 WHSI(TV) Smithtown, N.Y., satellite (1)
Ch. 46 KHSC(TV) Los Angeles (2) 2.625%
Ch. 60 WEHS(TV) Chicago (3) 1.735%
Ch. 65 WHSP(TV) Vineland, N.J. (4) 1.49%
Ch. 66 WHSH(TV) Boston (6) 1.155%
Ch. 49 KHSX(TV) Dallas (8) .93%
Ch. 67 KHSH(TV) Houston (10) .825%
Ch. 61 WQHS(TV) Cleveland (11) .795%
Ch. 50 WBHS(TV) Tampa, Fla. (14) .695%
Ch. 24 WHSW(TV) Baltimore (22) .51%

7. Gillett Group Inc.
(12.325%)

Ch. 38 WSBK-TV Boston (6) 1.155%
Ch. 2 WJBK-TV Detroit (7) 1.91%
Ch. 8 WJW-TV Cleveland (11) 1.59%
Ch. 5 WAGA-TV Atlanta (12) 1.43%
Ch. 13 WTVT(TV) Tampa, Fla. (14) 1.39%
Ch. 2 WMAR-TV Baltimore (22) 1.02%
Ch. 39 KCST-TV San Diego (25) .91%
Ch. 6 WITI-TV Milwaukee (30) .79%
Ch. 4 WSMV(TV) Nashville (32) .77%
Ch. 8 KSBW-TV Salinas (63) .46%
Ch. 13 WOKR(TV) Rochester, N.Y. (72) .39%
Ch. 11 KGIN(TV) Grand Island, Neb. (92) .29%
Ch. 6 KSBY-TV San Luis Obispo (113) .22%

8. Chris Craft Industries
(10.545%)

Ch. 13 KCOP(TV) Los Angeles (2) 5.25%
Ch. 44 KBHK-TV San Francisco (5) 1.205%
Ch. 9 KMSP-TV Minneapolis (13) 1.39%
Ch. 45 KUTP(TV) Phoenix (21) .52%
Ch. 12 KPTV(TV) Portland, Ore. (26) .90%
Ch. 4 KTVX(TV) Salt Lake City (40) .66%
Ch. 4 KMOL-TV San Antonio, Tex. (42) .62%

9. Group W
(10.06%)

Ch. 3 KYW-AM-TV Philadelphia (4) 2.98%
Ch. 5 KPIX(TV) San Francisco (5) 2.41%
Ch. 4 WBZ-AM-TV Boston (6) 2.31%
Ch. 2 KDKA-AM-TV Pittsburgh (17) 1.34%
Ch. 13 WJZ-TV Baltimore (22) 1.02%

10. Gannett
(9.91%)

Ch. 56 WLVI-TV Boston (6) 1.155%
Ch. 9 WUSA(TV) Washington (9) 1.79%
Ch. 11 WXIA-TV Atlanta (12) 1.43%
Ch. 11 KARE(TV) Minneapolis (13) 1.39%
Ch. 9 KUSA-TV Denver (19) 1.15%
Ch. 12 KPNX-TV Phoenix (21) 1.04%
Ch. 5 KOCO-TV Oklahoma City (37) .69%
Ch. 2 WFMY-TV Greensboro, N.C. (50) .57%
Ch. 12 WTLV(TV) Jacksonville, Fla. (57) .5%
Ch. 24 KVUE-TV Austin, Tex. (71) .195%

11. Telemundo Group Inc.
(9.21%)

Ch. 47 WNJU-TV Linden, N.J. (1) 3.87%
Ch. 52 KVEA(TV) Corona, Calif. (2) 2.625%
Ch. 48 KSTS(TV) San Jose (San Francisco) (5) 1.205%
Ch. 48 New TV* Galveston, Tex. (10) .825%
Ch. 51 WSCV(TV) Fort Lauderdale, Fla. (16) .685%
Ch. 4 WKAQ-TV San Juan, P.R. NR**

12. Cox Enterprises Inc.
(8.985%)

Ch. 2 KTVU(TV) Oakland, Calif. (5) 2.41%
Ch. 50 WKBD(TV) Detroit (7) .955%
Ch. 2 WSB-TV Atlanta (12) 1.43%
Ch. 11 WPXI(TV) Pittsburgh (17) 1.34%
Ch. 30 KDNL-TV St. Louis (18) .61%
Ch. 9 WFTV(TV) Orlando (27) .88%
Ch. 9 WSOC-TV Charlotte, N.C. (31) .78%
Ch. 7 WHIO-TV Dayton, Ohio (48) .58%

13. Spanish International
(8.925%)

Ch. 41 WXTV(TV) Paterson, N.J. (1) 3.87%
Ch. 34 KMEX-TV Los Angeles (2) 2.625%
Ch. 14 KDTV(TV) San Francisco (5) 1.205%
Ch. 23 WLTV(TV) Miami (16) .685%
Ch. 41 KWEX-TV San Antonio, Tex. (42) .31%
Ch. 21 KFTV(TV) Hanford, Calif. (63) .23%

14. MCA
(7.74%)

Ch. 9 WWOR-TV New York (1) 7.74%

15. TVX Broadcast Group Inc.
(7.555%)

Ch. 29 WTAF-TV Philadelphia (4) 1.49%
Ch. 21 KTXA(TV) Fort Worth (8) .93%
Ch. 20 WDCA(TV) Washington (9) .895%
Ch. 20 KTXH(TV) Houston (10) .825%
Ch. 6 WCIX(TV) Miami (16) 1.37%
Ch. 30 WCAY-TV Nashville (32) .385%
Ch. 38 WNOL-TV New Orleans (34) .365%
Ch. 22 WLFL-TV Raleigh, N.C. (35) .35%
Ch. 30 WMKW-TV Memphis (41) .33%
Ch. 35 KRRT(TV) Kerrville, Tex. (42) .31%
Ch. 33 WTVZ(TV) Norfolk, Va. (43) .305%

16. Scripps Howard Broadcasting Co.
(7.3%)

Ch. 7 WXYZ-TV Detroit (7) 1.91%
Ch. 5 WEWS(TV) Cleveland (11) 1.59%
Ch. 28 WFTS(TV) Tampa (14) .695%
Ch. 15 KNXV-TV Phoenix (21) .52%
Ch. 41 KSHB-TV Kansas City, Mo. (28) .405%
Ch. 9 WCPO-TV Cincinnati (29) .81%
Ch. 5 WMC-TV Memphis (41) .33%
Ch. 5 WPTV(TV) West Palm Beach, Fla. (53) .52%
Ch. 2 KJRH(TV) Tulsa, Okla. (54) .52%

17. Hearst Broadcasting Group.
(6.85%)

Ch. 5 WCVB-TV Boston (6) 2.31%
Ch. 4 WTAE-TV Pittsburgh (17) 1.34%
Ch. 11 WBAL-TV Baltimore (22) 1.02%
Ch. 9 KMBC-TV Kansas City, Mo. (29) .81%
Ch. 12 WISN-TV Milwaukee (30) .79%
Ch. 2 WDTN(TV) Dayton, Ohio (48) .58%

18. RKO
(5.91%)

Ch. 9 KHJ-TV Los Angeles (2) 5.25%
Ch. 13 WHBQ-TV Memphis (41) .66%

19. A.H. Belo
(5.69%)

Ch. 8 WFAA-TV Dallas (8) 1.86%
Ch. 11 KHOU-TV Houston (10) 1.65%
Ch. 10 KXTV(TV) Sacramento, Calif. (20) 1.05%
Ch. 13 WVEC-TV Hampton, Va. (43) .61%
Ch. 6 KOTV(TV) Tulsa, Okla. (54) .52%

20. Gaylord
(5.255%)

Ch. 11 KTVT Fort Worth (8) 1.86%
Ch. 39 KHTV Houston (10) .825%
Ch. 43 WUAB Cleveland (11) .795%
Ch. 11 KSTW Seattle (15) 1.38%
Ch. 18 WVTV Milwaukee (30) .395%

*Coverage when station is completed, pending FCC approval.

**TV Groups with stations in markets not rated by Arbitron must supply audience reach figures to the FCC, but only at the time of a sale.

Appendix B: Fall Arbitron Report

Fall Arbitron report finds WHTZ number one in New York; KPWR on top in Los Angeles, and WGCI-FM and WGN(AM) sharing lead in Chicago

Hit music is the order of the day in both New York and Los Angeles, according to the just-released fall 1987 Arbitron market reports. Meanwhile, in Chicago, urban contemporary WGCI-FM has tied long-time MOR powerhouse WGN(AM) for the top spot in 12-plus metro share. Arbitron's fall reports reflect local listener surveys from Sept. 24 through Dec. 16, 1987.

■ Contemporary hit WHTZ(FM) remained the single most popular radio station in New York this past fall with a 6.0 12-plus share, Monday-Sunday, 6 a.m.-midnight. Second place went to all-news WINS(AM) at 5.0, which inched up from 4.3 and fifth place in the summer report. There was a tie for third between light contemporary WLTW-FM and contemporary hit WWPR(FM) (formerly WPLJ[FM]), with each outlet registering 4.7.

Other top market rankings include urban contemporary WRKS-FM at 4.6, talk WOR(AM) with 4.5 , and easy listening WPAT-FM at 4.4.

However, when the easy listening simulcast of WPAT(AM), which posted a 1.6, and WPAT-FM are combined, the stations tie WHTZ for first place at 6.0.

All-sports WFAN(AM) dipped considerably in the new report, going from 2.3 in the summer when it was airing New York Mets baseball—its first book since the station switched from country to sports—to 1.2. Other stations that dropped from the summer book include talk WABC(AM), from 2.9 to 2.4; urban contemporary WBLS(FM), 4.8 to 4.1; oldies WCBS-FM, 3.8 to 3.6, and contemporary hit/dance WQHT(FM), 4.3 to 3.7.

In the battle for the FM album rock audience, both AOR WNEW-FM and its cross-town rival, classic rocker WXRK(FM), have lost overall audience share from the previous report. WNEW went from 4.0 to 3.3 while WXRK fell from 3.7 to 2.8.

Among the stations registering overall metro share gains were all-news WCBS(AM),

up slightly from 3.1 to 3.2; WYNY(FM), 1.9 to 2.7 under its new country format; Spanish-language WADO(AM), 1.8 to 2.4, and light contemporary WNSR(FM), 2.8 to 2.9. Adult contemporary WNBC(AM) held steady from the last book with a 1.3 12-plus metro share.

■ In Los Angeles, the top five stations in the summer report repeated their rankings in the fall. Contemporary hit/dance KPWR(FM) maintained its number-one status from the summer with a 7.5 overall share—up from 6.6. Landing second was contemporary hit KIIS-FM at 6.9. (Contemporary hit KIIS[AM] had a 0.3; when combined, the stations post a 7.2.).

Rounding out the top five spots were talk KABC(AM), 5.5; light contemporary KOST(FM), 4.5 and easy listening KJOI(FM), 4.3.

Showing a marked increase from the summer book was all-news KFWB(AM), which rose from 2.6 to 4.2. The market's other all-news operation, KNX(AM), also climbed in overall share from 2.8 to 3.2.

Also on the rise were two of the market's rock outlets: KLOS(FM), up from 3.0 in summer 1987 to 3.8 and KLSX(FM), which programs classic rock, from 3.0 to 3.6. However, progressive rocker KROQ(FM) dropped from 4.3 to 3.7.

Other stations that went up from the summer survey period include oldies KRTH-FM, from 3.3 to 3.7; Spanish-language KTNQ(AM), 2.3 to 3.0, and light contemporary KIQQ(FM), 2.7 to 2.8. Among those on the down side were light contemporary KBIG(FM), 4.3 to 4.0; MOR KMPC(AM), 2.8 to 2.5; country KZLA(AM), 2.5 to 2.1, and contemporary black KJLH(FM), 2.2 to 1.8.

KTWV(FM), which premiered "The Wave" (new age/light jazz and soft rock) last year, a format that turned out to be the talk of the industry, also lost ground in the 12-plus category this past fall, slipping from 2.7 to 2.3.

■ For Chicago, both urban contemporary WGCI-FM and MOR WGN(AM) tied for top honors in 12-plus metro share with 8.0. WGN fell from a 9.7 reading in the summer while WGCI dipped from 8.2.

The two leading stations were followed by all-news WBBM(AM) with 6.3 (the same share it had in the summer), easy listening WLOO(FM), 5.4 and urban contemporary WBMX(FM) and album-rocker WLUP(FM), both 4.5.

Adult contemporary WFYR(FM) fell in overall metro share from the previous report, going from 2.9 to 2.0 while light contemporary WLAK(FM) rebounded from 3.3 to 3.7. The station had a 4.2 in the spring. The same was true of light contemporary WCLR-FM, which moved from 2.7 to 3.0.

Among the market's top 40 rockers, WYTZ(FM) has gone up steadily since the spring 1987 report when it finished with a 2.7 12-plus share. Last summer, it had a 3.5 and in the new fall report it pulled a 3.9. WBBM(FM), on the other hand, dipped slightly from the summer (4.1) to the fall (3.9). Also dropping was adult contemporary WLS(AM), which is co-owned with WYTZ. It went from 2.5 in the spring to 2.2 in the summer to 1.8.

New age music pushed WNUA(FM) to a higher overall share. WNUA went from a 1.2 in the summer (it programed classic hits as WRXR), to a 1.8.

Appendix C: 1987-1988 Network Primetime Season at a Glance

ABC-TV

Series Title	Day	Hr.	Mins.	Supplier	Production Principals	Cast Regulars & Semi-Regulars	Estimated Prod. Fee per Episode
ABC Thursday Night Movie	Thu	9:00	120	Various			$2,600,000
Buck James	Sun	10:00	60	Robert E. Fuisz-William F. Storke Prods.-Tri-Star TV	EP: Robert E. Fuisz, William F. Storke P: Bob Birnbaum, David Abramowitz, Paul Edwards, Garner Simmons	Dennis Weaver, Alberta Watson, Shannon Wilcox, Elena Stiteler, Jon Maynard Pennell, Dehl Berti, John Cullum	875,000
Charmings, The	Thu	8:30	30	Sternin & Fraser Ink, Inc.-Columbia/Embassy TV	EP: Robert Sternin, Prudence Fraser SP: Ellen Guylas P: Mark Fink, Al Lowenstein D: Jack Shea	Christopher Rich, Carol Huston, Judy Parfitt, Cork Hubbert, Brandon Call, Garette Ratliff, Paul Eiding, Dori Brenner, Paul Winfield	375,000
Disney Sunday Movie, The	Sun	7:00	60	Walt Disney TV			1,200,000
Dolly	Sun	9:00	60	Sandollar Prods.-Don Mischer Prods.	EP: Sandy Gallin P: Don Mischer CP: Al Rogers, Tom Tenowich D. Don Mischer, Jeff Margolis	Dolly Parton	1,000,000
Dynasty	Wed	10:00	60	Richard & Esther Shapiro Prods.-Aaron Spelling Prods.	EP: Aaron Spelling, Douglas S. Cramer, Richard & Esther Shapiro SP: E. Duke Vincent, Elaine Rich, Eileen & Robert Pollock P: Edward DeBlasio	John Forsythe, Linda Evans, John James, Gordon Thomson, Jack Coleman, Michael Nader, Heather Locklear, Emma Samms, Terri Garber, Leann Hunley, James Healey, Joan Collins, William Beckley	1,200,000
Full House	Fri	8:00	30	Jeff Franklin Prods.-Miller-Boyett Prods.-Lorimar-Telepictures	EP: Jeff Franklin, Thomas L. Miller, Robert L. Boyett P: Don Van Atta D: Joel Zwick	John Stamos, Bob Saget, David Coulier, Candace Cameron, Jodie Sweetin, Mary Kate Olsen	350,000
Growing Pains	Tue	8:30	30	Warner Bros. TV	EP: Michael Sullivan, Dan Guntzelman, Steve Marshall D: John Tracy	Alan Thicke, Joanna Kerns, Kirk Cameron, Tracey Gold, Jeremy Miller	400,000
Head Of The Class	Wed	8:30	30	Eustis Elias Prods.-Warner Bros. TV	EP: Rich Eustis & Michael Elias P: Alan Rosen	Howard Hessman, William G. Schilling, Jeannetta Arnette, Leslie Bega, Dan Frischman, Robin Givens, Khrystyne Haje, Jory Husain, Tony O'Dell, Brian Robbins, Kimberly Russell, Dan Schneider, Tannis Vallely	375,000
Hooperman	Wed	9:00	30	Adam Prods.-20th Fox TV	EP: Robert M. Myman, Leon Tokatyan P: Robert Goodwin	John Ritter, Barbara Bosson, Alix Elias, Clarence Felder, Joseph Gian, Debrah Farentino, Felton Perry, Sydney Walsh	350,000
Hotel	Sat	10:00	60	Aaron Spelling Prods.	EP: Aaron Spelling, Douglas S. Cramer SP: E. Duke Vincent P: Tom Swale & Duane Poole, Dennis Hammer	James Brolin, Connie Selleca, Nathan Cook, Shari Belafonte-Harper, Valerie Landsburg, Susan Walters, Ty Miller	850,000
I Married Dora	Fri	8:30	30	Reeves Entertainment Group	EP: Michael Leeson, Chick Mitchell & Geoffrey Neigher P: Wendy Blair, Jace Richdale, Vic Rauseo & Linda Morris CP: Mark Masuoka	Daniel Hugh Kelly, Elizabeth Pena, Sanford Jensen, Juliette Lewis, Jason Horst, Henry Jones	350,000

Series Title	Day	Hr.	Mins.	Supplier	Production Principals	Cast Regulars & Semi-Regulars	Estimated Prod. Fee per Episode
MacGyver	Mon	8:00	60	Henry Winkler/-John Rich Prods.-Paramount TV	EP: Henry Winkler, John Rich, Steve Downing SP: Cal Clements Jr. P: Michael Greenburg, Steve Kandel CP: John Whelpley	Richard Dean Anderson, Dana Elcar, Bruce McGill, Elyssa Davalos	775,000
Max Headroom	Fri	9:00	60	Lakeside/Chrysalis Prods.-Lorimar-Telepictures	EP: Peter Wagg SP: Andrew Adelson P: Brian Frankish CP: Steve Roberts	Matt Frewer, Amanda Pays, George Coe, Chris Young, W. Morgan Sheppard, Jeffrey Tambor, Concetta Tomei, Hank Garrett, Lee Wilkof, Sharon Barr	750,000
Moonlighting	Tue	9:00	60	Picturemaker Prods.-ABC Circle Films	EP: Glenn Gordon Caron, Jay Daniel SP: Artie Mandelberg, Roger Director Sr. P: Ron Osborn, Jeff Reno P: Charles Eglee CP: Chris Welch	Cybill Shepherd, Bruce Willis, Allyce Beasley, Curtis Armstrong, Eva Marie Saint, Robert Webber	1,000,000
NFL Monday Night Football .	Mon	9:00	120	ABC Sports	EP: Roone Arledge P: Ken Wolfe D: Larry Kamm	Al Michaels, Frank Gifford, Dan Dierdorf	2,500,000
Ohara	Sat	9:00	60	Warner Bros. TV-Imagine Films Entertainment-Kurissama Prods.	EP: Brian Grazer, Tony Wharmby SP: Robert McCullough P: Skip Ward	Pat Morita, Robert Clohessy, Rachel Ticotin, Meagan Fay	750,000
Once A Hero	Sat	8:00	60	Garden Party Prods.- New World TV	EP: Dusty Kay P: Ira Steven Behr	Jeff Lester, Robert Forster, Caitlin Clark, Josh Blake, Milo O'Shea, David Wohl	750,000
Perfect Strangers	Wed	8:00	30	Miller-Boyett Prods.-Lorimar-Telepictures	EP: Thomas L. Miller, Robert L. Boyett SP: William Bickley & Michael Warren P: Paula A. Roth, James O'Keefe D: Joel Zwick	Bronson Pinchot, Mark Linn-Baker, Melanie Wilson, Rebeca Arthur, Jo Marie Payton-France	375,000
'Slap' Maxwell Story, The ...	Wed	9:30	30	Slap Happy Prods.	EP: Bernie Brillstein P: Jay Tarses CP: Bob Brush, Roz Doyle	Dabney Coleman, Megan Gallagher, Brian Smiar, Bill Cobbs, Susan Anspach, Bill Calvert	350,000
Sledge Hammer	Thu	8:00	30	Alan Spencer Prods.-New World TV	EP: Alan Spencer SP: Ron Friedman P: Tom Kane CP: Jim Ragan	David Rasche, Anne-Marie Martin, Harrison Page	350,000
Spenser: For Hire	Sun	8:00	60	Warner Bros. TV	EP: Bill Yates, Stephen Hattman SP: Michael Fisher P: Michael Maschio	Robert Urich, Avery Brooks, Barbara Stock, Ron McLarty, Richard Jaeckel, Kenneth Walsh	825,000
thirtysomething	Tue	10:00	60	Bedford Falls Prods.-MGM/UA TV	EP: Marshall Herskovitz, Edward Zwick SP: Paul Haggis P: Scott Winant	Timothy Busfield, Polly Draper, Mel Harris, Peter Horton, Melanie Mayron, Ken Olin, Patricia Wettig	750,000
20/20	Fri	10:00	60	ABC News	EP: Victor Neufeld Sr. P: Jeff Diamond D: Michael Buddy W: Jerry Tully	Hugh Downs, Barbara Walters, Bob Brown, Tom Jarriel, Stone Phillips, Lynn Sherr, John Stossel	500,000
Who's The Boss?	Tue	8:00	30	Columbia/Embassy TV	EP: Blake Hunter, Martin Cohan SP: Howard Meyers P: John Anderson, Karen Wengrad, Ken Cinnamon D: Asaad Kelada	Tony Danza, Judith Light, Alyssa Milano, Danny Pintauro, Katherine Helmond	475,000

CBS-TV

Series Title	Day	Hr.	Mins.	Supplier	Production Principals	Cast Regulars & Semi-Regulars	Estimated Prod. Fee per Episode
Beauty & The Beast	Fri	8:00	60	Ron Koslow Films-Witt-Thomas Prods.-Republic Pictures	EP: Paul Junger Witt, Tony Thomas SP: Ron Koslow P: David Peckinpah, Andrew Laskos, Harvey Frand	Linda Hamilton Ron Perlman, Roy Dotrice, Jay Acovone, Ren Woods, John McMartin	750,000

Series Title	Day	Hr.	Mins.	Supplier	Production Principals	Cast Regulars & Semi-Regulars	Estimated Prod. Fee per Episode
CBS Sunday Movies	Sun	9:00	120	Various			2,600,000
Cagney & Lacey	Mon	10:00	60	Mace Neufeld Prods.-Barney Rosenzweig Prods.- Orion TV	EP: Barney Rosenzweig SP: Jonathan Estrin, Shelley List P: Ralph S. Singleton CP: P.K. Knelman	Tyne Daly, Sharon Gless, Al Waxman, Martin Kove, Harvey Atkin, Merry Clayton, Robert Hegyes, John Karlen, Stephen Macht, Tony LaTorre, Troy Slaten, Paul Mantee	950,000
Dallas	Fri	9:00	60	Lorimar-Telepictures	EP: Leonard Katzman SP: Arthur Bernard Lewis P: David Paulsen	Barbara Bel Geddes, Patrick Duffy, Linda Gray, Larry Hagman, Steve Kanaly, Howard Keel, Ken Kercheval, Priscilla Beaulieu Presley, Sheree J. Wilson, Jack Scalia, Andrew Stevens, Bert Remsen, Leigh Taylor-Young, Amy Stock	1,200,000
Designing Women	Mon	9:30	30	Harry Thomason-Linda Bloodworth Thomason Mozark Prods.-Columbia Pictures TV	EP: Harry Thomason, Linda Bloodworth Thomason P: Douglas Jackson, Tommy Thompson	Delta Burke, Dixie Carter, Annie Potts, Jean Smart, Meshach Taylor, Hal Holbrook, Richard Gilliand	350,000
Equalizer, The	Wed	10:00	60	Universal TV	EP: James McAdams, Ed Waters SP: Coleman Luck, Scott Shepherd P: Marc Laub, Daniel Lieberstein CP: Peter Runfolo, Robert Eisele	Edward Woodward, Kieth Szarabajka, Robert Lansing, William Zabka, Chad Redding	825,000
Everything's Relative	Sat	8:30	30	Fredde Prods.-Columbia/Embassy TV	EP: Maurice Duke, Richard Heller CP: Marshall Karp, Debbie Elbin Penchina	Jason Alexander, John Bolger, Gina Hecht, Tony Deacon Nittoli, Anne Jackson	350,000
Falcon Crest	Fri	10:00	60	Amanda & MF Prods.-Lorimar-	EP: Joanna Brough, Jeff Freilich, Michael Filerman P: John F. Perry	Jane Wyman, Robert Foxworth, David Selby, Lorenzo Lamas, Ana-Alicia, Brett Cul- Sparks, Chao-Li Chi, Susan Sullivan, Leslie Caron, Ed Marinaro, Ursula Andress, Rod Taylor	1,100,000
Frank's Place	Mon	8:00	30	Viacom Prods.	EP: Hugh Wilson, Tim Reid P: David Chambers, Max Tash	Tim Reid, Robert Harper, Daphne Maxwell Reid, Francesca P. Roberts, Frances E. Williams, Virginia Capers, Tony Burton, Charles Lampkin, Lincoln Kilpatrick, William Thomas Jr., Don Yesso	350,000
Houston Knights	Tue	8:00	60	Jay Bernstein Prods.-Columbia/Embassy TV	EP: Jay Bernstein SP: Gregory S. Dinallo CP: Jeff Morton, Bill Cairncross	Michael Pare, Michael Beck, John Hancock, Robyn Douglass	750,000
Jake & The Fatman	Tue	9:00	60	Fred Silverman Co.-Strathmore Prods.-Viacom Prods.	EP: Fred Silverman, Dean Hargrove, Sam Rolfe SP: Robert Hamilton, Philip Saltzman P: Bill Sandefur, Barry Steinberg	William Conrad, Joe Penny, Alan Campbell, Rebecca Bush, Lu Leonard	750,000
Kate & Allie	Mon	8:00	30	Mort Lachman & Associates-Reeves Entertainment Group	EP: Merrill Grant, Mort Lachman SP: George Barimo P: Bill Persky, Bob Randall D: Bill Persky	Susan Saint James, Jane Curtin, Ari Meyers, Frederick Koehler, Allison Smith	450,000
Knots Landing	Thu	10:00	60	Roundelay/MF Prods.-Lorimar-Telepictures	EP: David Jacobs, Michael Filerman P: Lawrence Kasha, Mary-Catherine Harold	Teri Austin, William Devane, Kevin Dobson, Julie Harris, Michele Lee, Donna Mills, Ted Shackelford, Joan Van Ark, Red Buttons, Michael York, Pat Petersen, Tonya Crowe, Nicolette Sheridan	1,100,000
Law & Harry McGraw, The ..	Tue	10:00	60	Universal TV	EP: Peter S. Fischer SP: Robert F. O'Neill P: Tom Sawyer	Jerry Orbach, Barbara Babcock, Shea Farrell, Juli Donald, Peter Haskell	750,000
Leg Work	Sat	9:00	60	Treasure Island Prods.-20th Fox TV	EP: Frank Abatemarco CP: John Starke	Margaret Colin, Frances McDormand, Patrick James Clarke	750,000

Series Title	Day	Hr.	Mins.	Supplier	Production Principals	Cast Regulars & Semi-Regulars	Estimated Prod. Fee per Episode $2,600,000
Magnum, P.I.	Wed	9:00	60	Universal-TV-Bel-isarius Prods.-Glen A. Larson Prods.-TWS Prods.	EP: Donald P. Bellisario, Chas. Floyd Johnson, Tom Selleck SP: Chris Abbott P: Rick Weaver, Jeri Taylor, Stephen A. Miller	Tom Selleck, John Hillerman, Roger E. Mosley, Larry Manetti, Kathleen Lloyd, Jean Bruce Scott, Elisha Cook, Kwan Hi Lim	1,000,000
Murder, She Wrote	Sun	8:00	60	Univeral TV	EP: Peter S. Fischer P: Robert F. O'Neill	Angela Lansbury	900,000
My Sister Sam	Sat	8:00	30	Pony Prods.-Warner Bros. TV	EP: Diane English SP: Karyl Miller, Korby Siamis CP: Danny Jacobson	Pam Dawber, Jenny O'Hara, Joel Brooks, David Naughton, Rebecca Schaeffer	350,000
Newhart	Mon	9:00	30	MTM Prods.	EP: Douglas Wyman, David Mirkin CP: Arnie Kogen	Bob Newhart, Mary Frann, Peter Scolari, Julia Duffy, Tom Poston, William Sanderson, Tony Papenfuss, John Voldstad	500,000
Oldest Rookie, The	Wed	8:00	60	Gil Grant Prods.-Chapman Prods.-Touchstone TV	EP: Richard Chapman, Gil Grant SP: Ric Rondell, Tom & Jo Perry P: Tom Chehak	Paul Sorvino, D.W. Moffett, Raymond J. Barry, Marshall Bell, Patrick Cronin	750,000
60 Minutes	Sun	7:00	60	CBS News	EP: Don Hewitt Sr. P: Philip Scheffler D: Arthur Bloom	Mike Wallace, Morley Safer, Harry Reasoner, Ed Bradley, Diane Sawyer, Andy Rooney	550,000
Tour Of Duty	Thu	8:00	60	Zev Braun Pictures-New World TV	EP: Zev Braun, Bill L. Norton SP: Rick Husky P: Ronald L. Schwary CP: Steve Bello	Terence Knox, Stephen Caffrey, Joshua Maurer, Steve Akahoshi, Tony Becker, Eric Bruskotter, Stan Foster, Ramon Franco, Miguel A. Nunez Jr.	850,000
West 57th	Sat	10:00	60	CBS News	EP: Andrew Lack Sr. P: Tom Yellin SP: Maurice Murad D: Andrew Lack	Jane Wallace, Steve Kroft, John Ferrugia, Meredith Vieira, Bob Sirott	500,000
Wiseguy	Thu	9:00	60	Stephen J. Cannell Prods.	EP: Stephen J. Cannell, Les Sheldon SP: Jo Swerling Jr., David Burke P: Stephen Kronish, Derek Kavanagh	Ken Wahl, Jonathan Banks, Jim Byrnes, Ray Sharkey, Gerald Anthony	750,000

NBC-TV

Series Title	Day	Hr.	Mins.	Supplier	Production Principals	Cast Regulars & Semi-Regulars	Estimated Prod. Fee per Episode
A Different World	Thu	8:30	30	Carsey-Werner Co.-Bill Cosby	EP: Marcy Carsey, Tom Werner, Anne Beatts SP: Thad Mumford P: George Crosby D: Ellen Falcon	Lisa Bonet, Dawnn Lewis, Marisa Tomei, Ted Ross, Jasmine Guy, Phyllis Stickney, Kadeem Hardison, Loretta Devine	350,000
A Year In The Life	Tue	9:00	60	Universal TV	EP: Joshua Brand, John Falsey SP: Stephen Cragg	Richard Kiley, Trey Ames, Adam Arkin, Jayne Atkinson, David Oliver, Sarah Jessica Parker, Amanda Peterson, Wendy Phillips, Morgan Stevens	750,000
ALF	Mon	8:00	30	Alien Prods.	EP: Bernie Brillstein, Tom Patchett P: Paul Fusco CP: Bob Bendetson	Max Wright, Anne Schedeen, Andrea Elson, Benji Gregory, ALF, Liz Sheridan, John LaMotta	400,000
Amen	Sat	9:30	30	Carson Prods. Group	EP: Ed. Weinberger, Peter Noah, Artie Julian SP: Mark Grosfan P: Eric Cohen CP: Reuben Cannon	Sherman Hemsley, Clifton Davis, Anna Maria Horsford, Barbara Montgomery, Roz Ryan, Jester Hairston, Franklyn Seales	375,000
Cheers	Thu	9:00	30	Charles/Burrows/-Charles Prods.-Paramount TV	EP: Glen & Les Charles, James Burrows P: David Angell, Peter Casey, David Lee CP: Tim Berry D: James Burrows	Ted Danson, Rhea Perlman, John Ratzenberger, Woody Harrelson, Kelsey Grammer, George Wendt, Kirstie Alley	550,000
Cosby Show, The	Thu	8:00	30	Carsey-Werner Co.-Bill Cosby	EP: Marcy Carsey, Tom Werner, John Markus SP: Carmen Finestra P: Gary Kott	Bill Cosby, Phylicia Rashad, Sabrina LeBeauf, Malcolm-Jamal Warner, Tempestt Bledsoe, Keshia Knight Pulliam, Geoffrey Owens, Deon Richmond, Carl Price	575,000

Series Title	Day	Hr.	Mins.	Supplier	Production Principals	Cast Regulars & Semi-Regulars	Estimated Prod. Fee per Episode
Crime Story	Tue	10:00	60	Michael Mann Co.-New World TV	EP: Michael Mann P: Michael Jaffe CP: Mark Rosner	Dennis Farina, Anthony Denison, Stephen Lang, Bill Smitrovich, Steve Ryan, William Campbell, Paul Butler, John Santucci	950,000
Facts Of Life, The	Sat	8:00	30	Embassy Communications	EP: Irma Kalish SP: Doug Arango & Phil Doran P: Rita Dillon, Ross Brown D: John Bowab	Cloris Leachman, Lisa Whelchel, Kim Fields, Mindy Cohn, Nancy McKeon, MacKenzie Astin, Sherrie Krenn	550,000
Family Ties	Sun	8:00	30	UBU Prods.-Paramount TV	EP: Gary David Goldberg, Alan Uger SP: Marc Lawrence P: Susan Borowitz, Carol Himes	Meredith Baxter Birney, Michael Gross, Michael J. Fox, Justine Bateman, Tina Yothers, Brian Bonsall, Courteney Cox	550,000
Golden Girls, The	Sat	9:00	30	Witt Thomas Harris Prods.-Touchstone TV	EP: Paul Kunger Witt, Tony Thomas, Kathy Speer, Terry Grossman SP: Mort Nathan, Barry Fanaro P: Winifred Harvey CP: Marsha Posner Williams, Frederic Weiss, Jeffrey Ferro	Bea Arthur, Betty White, Rue McClanahan, Estelle Getty	500,000
Highway To Heaven	Wed	8:00	60	Michael Landon Prods.	EP: Michael Landon P: Kent McCray D: Michael Landon, Victor French	Michael Landon, Victor French	850,000
Hunter	Sat	10:00	60	Stephen J. Cannell Prods.	EP: Roy Huggins SP: Jo Swerling Jr. P: Stuart Segall	Fred Dryer, Stepfanie Kramer, Charles Hallahan, Garrett Morris	825,000
J.J. Starbuck	Tue	9:00	60	Stephen J. Cannell Prods.	Ep: Stephen J. Cannell, Babs Greyhosky SP: Jo Swerling Jr. P: Alex Beaton	Dale Robertson	750,000
L.A. Law	Thu	9:00	60	20th Fox TV	EP: Steven Bochco, Gregory Hoblit SP: Terry Louise Fisher P: Scott Goldstein	Harry Hamlin, Susan Dey, Jill Eikenberry, Corbin Bernsen, Richard Dysart, Michael Tucker, Michele Greene, Alan Rachins, Jimmy Smits, Susan Ruttan, Brian Underwood	950,000
Matlock	Tue	8:00	60	Fred Silverman Co.-Strathmore Prods.-Viacom	EP: Fred Silverman, Dean Hargrove SP: Joel Steiger P: Richard Collins CP: Jeff Peters	Andy Griffith, Nancy Stafford, Kene Holliday, Kari Lizer, Julie Sommars	775,000
Miami Vice	Fri	9:00	60	Michael Mann Co.-Universal TV	EP: Michael Mann, George Geiger P: Richard Brams CP: Michael Attanasio	Don Johnson, Philip Michael Thomas, Michael Talbott, Saundra Santiago, Olivia Brown, Edward James Olmos	1,000,000
My Two Dads	Sun	8:30	30	Michael Jacobs Prods.-Tri-Star TV	EP: Michael Jacobs SP: Bob Myer, Bob Young P: Danielle Alexandra CP: Phil Kellard & Tom Moore, Teresa O'Neill	Paul Reiser, Staci Keanan, Florence Stanley, Greg Evigan	350,000
NBC Monday Night At The Movies	Mon	9:00	120	Various			2,600,000
NBC Sunday Night At The Movies	Sun	9:00	120	Various			2,600,000
Night Court	Thu	9:30	30	Starry Night Prods.-Warner Bros. TV	EP: Reinhold Weege SP: Jeff Melman P: Linwood Boomer, Tom Straw CP: Tim Steele	Harry Anderson, Markie Post, John Larroquette, Charles Robinson, Richard Moll, Marsha Warfield	500,000
Our House	Sun	7:00	60	Blinn/Thorpe Prods.-Lorimar-Telepictures	EP: William Blinn, Jerry Thorpe P: Jerry McNeely, Ernie Wallengren	Wilford Brimley, Deidre Hall, Shannen Doherty, Chad Allen, Keri Houlihan, Gerald S. O'Loughlin	750,000
Private Eye	Fri	10:00	60	Universal TV	EP: Anthony Yerkovich SP: Scott Brazil P: Fred Lyle	Michael Woods, Josh Brolin, Bill Sadler, Lisa Jane Persky	750,000

Series Title	Day	Hr.	Mins.	Supplier	Production Principals	Cast Regulars & Semi-Regulars	Estimated Prod. Fee per Episode
Rags To Riches	Fri	8:00	60	Leonard Hill Films-New World TV	EP: Leonard Hill, Andy Schneider SP: Henry & Renee Longstreet P: Ron Gilbert CP: Chris Carter	Joe Bologna, Tisha Campbell, Blanca De-Garr, Kimiko Gelman, Bridget Michele, Heidi Zeigler, Douglas Seale	750,000
St. Elsewhere	Wed	10:00	60	MTM Enterprises	EP: Bruce Paltrow, Mark Tinker P: John Tinker, Channing Gibson	Ed Flanders, Norman Lloyd, Ronny Cox, Bonnie Bartlett, Ed Begley Jr., Stephen Furst, Bruce Greenwood, Eric Laneuville, Sagan Lewis, Howie Mandel, David Morse, France Nuyen, Cindy Pickett, Christina Pickles, Jennifer Savidge, Denzel Washington, William Daniels	1,000,000
227	Sat	8:30	30	Embassy TV	EP: Ron Bloomberg, George Burditt SP: Bill Boulware P: Ron Rubin, Roxie Wenk Evans D: Gerren Keith	Marla Gibbs, Hal Williams, Alaina Reed, Jackee, Helen Martin, Regina King, Curtis Baldwin, Kia Goodwin	375,000
Valerie's Family	Mon	8:30	30	Miller-Boyett Prods.-Lorimar-Telepictures	EP: Thomas L. Miller, Robert L. Boyett SP: Judy Pioli, Chip & Doug Keyes P: Richard Correll	Sandy Duncan, Jason Bateman, Danny Ponce, Jeremy Licht, Edie McClurg, Josh Taylor, Tom Hodges, Steve Witting, Willard Scott	375,000

Appendix D: Current Syndication at a Glance

Current Off-Network Half-Hours

Program	Distributor	Episodes	Terms	Available
2nd Hundred Years (Sold As Magic Show)	Screen Gems	26	C	Now
Alice	Warner Brothers	202	C	Now
All In The Family	Viacom	207	C	Now
Andy Griffith	Viacom	249	C	Now
Angie	Paramount	37	C	Now
Archie's Place	Embassy	97	C	Now
Barney Miller	Columbia	170	C	Now
Batman	20th Century Fox	120	C	Now
Benson	Columbia	120	C	Now
Best Of Groucho	WW Ent	130	C	Now
Beverly Hillbillies	Viacom	274	C	Now
Bewitched	D.F.S.	252	B(2/4)	Now
BJ/Lobo	MCA	86	C	Now
Bob Newhart Show	Viacom	142	C	Now
Bosom Buddies	Paramount	37	C	Now
Brady Bunch	Paramount	117	C	Now
Branded	King World	48	C	Now
Car 54, Where Are You?	Republic Pictures	60	C	Now
Carol Burnett Show	Burnett	150	C	Now
Carson Comedy	Columbia	130	C	Now
Cheers	Paramount	112	C	Now
Dark Shadows	Worldvision	260	C	Now
Dick Van Dyke	Viacom	158	C	Now
Different Strokes	Embassy	144	C	Now
Eye On Hollywood	Harmony Gold	65	B(2/4 +)	Now
Facts Of Life	Embassy	153	C	Now
Family Affair	Viacom	138	C	Now
Family Ties	Paramount	98	C	Now
Fantasy Island	Columbia	200	C	Now
Flying Nun	Colex	82	C	Now
Get Smart	Republic	138	C	Now
Gidget (Avail After Barter Run)	Colex	32	C	Now
Gilligan's Island	Turner Ent.	98	C	Now
Gimme A Break	MCA	85	C	Now
Girl With Something Extra (Sold As Magic Show)	Screen Gems	22	C	Now
Gomer Pyle	Viacom	150	C	Now
Good Times	Embassy	133	C	Now
Guns Of Will Sonnett	King World	50	C	Now
Happy Days	Paramount	255	C	Now
Harper Valley P.T.A.	MCA	29/23	B(2 +/3 +)	Now
Harper Valley P.T.A.	MCA	29	C	Now
Here's Lucy	Lorimar/Telepictures	144	C	Now
Hitchcock Presents	MCA	265	C	Now
Hogan's Heroes	Viacom	168	C	Now
Honeymooners	Viacom	107	C	Now
I Dream Of Jeannie	DFS	139	B(2/4)	Now
I Love Lucy	Viacom	179	C	Now
Jeffersons	Embassy	207	C	Now
Jennifer Slept Here (Sold As Magic Show)	Screen Gems	13	C	Now
Knight Rider	MCA	90	C	Now
Lassie	Colbert	192	C	Now
Laugh In	Lorimar/Telepictures	130	C +	Now
Laverne & Shirley	Paramount	178	C	Now
Leave It To Beaver	MCA	234	C	Now
Love Boat II	Worldvision	115	C	Now
Mash	20th Century Fox	255	C	Now
Maude	Embassy	142	C	Now
Mayberry RFD	Lorimar/Telepictures	78	C	Now
Mork & Mindy	Paramount	95	C	Now
Mr. Merlin (Sold As Magic Show)	Screen Gems	22	C	Now
My Favorite Martian	Lorimar/Telepictures	107	C	Now
Night Gallery	MCA	97	C	Now
One Day At A Time	Embassy	187	C	Now
Operation Petticoat	MCA	32/20	B(2 +/3 +)	Now
Operation Petticoat	MCA	32	C	Now
Partridge Family	DFS	96	B(2/4)	Now
Punky Brewster	Columbia	44	C	Now
Pvt. Benjamin	Warner Brothers	39	C	Now
Real McCoys	Screen Gems	130	C	Now
Real People	Lorimar/Telepictures	195	C	Now
Rifleman	Colbert	168	C	Now
Sanford & Son	Embassy	136	C	Now
Saturday Night Live	Orion	102	C +	Now
Show Of Shows (Best Of)	ZIV	65	C	Now
Silver Spoons	Columbia/Embassy	116	C	Now
Smith Family	Dionne	39	C	Now
Soap	Columbia	92	C	Now
Square Pegs	Embassy	20	C	Now
Tabatha (Sold As Magic Show)	Screen Gems	12	C	Now
Tales Of The Texas Rangers	Screen Gems	52	C	Now
Taxi	Paramount	93	C	Now
Temperature's Rising	Screen Gems	46	C	Now
That Girl	Worldvision	136	C	Now
That's Incredible	MCA	165	C	Now
That's My Mama	Columbia	39	C	Now
The Ropers	Taffner	26	C	Now
Three's A Crowd	Taffner	22	C	Now
Three's Company	Taffner	174	C	Now
To Rome With Love	Dionne	48	C	Now
Too Close For Comfort	Taffner	122	C	Now
Topper	King World	78	C	Now
Twilight Zone	Viacom	136	C	Now
Wanted, Dead Or Alive	Four Star	94	C	Now
We Love Lucy	Viacom	26	C	Now
What's Happening	Colex	65	C	Now
WKRP In Cincinnati	Victory	90	C	Now
Wyatt Earp	Screen Gems	130	C	Now

Current Off-Network Hours

Program	Distributor	Episodes	Terms	Available
12 O'Clock High	20th Century Fox	78	C	Now
A-Team	MCA	128	C	Now
Avengers	Orion	83	C	Now
Barnaby Jones	Worldvision	177	C	Now
BJ/Lobo	MCA	86	C	Now
Black Sheep Squadron	MCA	35	C + +	Now
Blue Knight	Lorimar-Telepictures	23	C	Now
Bonanza	Republic	268	C	Now
Buck Rogers	MCA	37	C	Now
Cannon	Viacom	124	C	Now
Charlie's Angels	Columbia	115	C	Now
Chips (Patrol)	MGM/UA	138	C	Now
Dallas	Lorimar-Telepictures	161	C	Now
Dukes Of Hazzard	Warner Brothers	143	C	Now
Dynasty	20th Century Fox	178	C	Now
Eight Is Enough	Lorimar-Telepictures	112	C	Now
Falcon Crest	Lorimar-Telepictures	157	C	Now
Fall Guy	20th Century Fox	111	C	Now
Fantasy Island	Columbia	130	C	Now
Flamingo Road	Lorimar-Telepictures	37	C	Now
Fridays	All American	52	B(5/7)	Now
Gunsmoke	Viacom	402	C	Now
Hart To Hart	Columbia	112	C	Now
Hawaii 5-0	Viacom	200	C	Now
Hawk	Colex	17	B(5/7)	Now
Here Come The Brides	Screen Gems	52	C	Now
High Chaparral	Republic	98	C	Now
Hill St. Blues	Victory	146	C	Now
Hitchcock Hour	MCA	93	C	Now
Incredible Hulk	MCA	85	C	Now
Ironhorse	Screen Gems	47	C	Now
Knight Rider	MCA	90	C	Now
Knots Landing	Lorimar/Telepictures	128	C	Now
Kojak	MCA	118	C	Now
Little House On The Prairie	Worldvision	216	C	Now
Lost In Space	20th Century Fox	83	C	Now
Lou Grant	Victory	114	C	Now
Love Boat I	Worldvision	140	C	Now
Love Boat II	Worldvision	115	C	Now
Magnum	MCA	129	C	Now
Mannix	Paramount	130	C	Now
Matt Houston	Warner Brothers	68	C	Now
Mission Impossible	Paramount	171	C	Now
Mystery Movies	MCA	124	C	Now
Naked City	Screen Gems	99	C	Now
Perry Mason	Viacom	271	C	Now
Police Story	Columbia	84	C	Now
Police Woman	Columbia	91	C	Now
Quincy	MCA	148	C	Now
Rawhide	Viacom	144	C	Now
Rockford Files	MCA	125	C	Now
Roller Derby	ABR Entertainment	56	C	Now
Route 66	Colex	52	B(5/7)	Now
Saturday Night Live	Orion	102	C	Now
Scarecrow & Mrs. King	Warner Bros.	88	C	Now
Simon And Simon	MCA	125	C	Now
Star Trek	Paramount	79	C	Now
Streets Of San Francisco	Worldvision	119	C	Now
T.J. Hooker	Columbia	90	C	Now
That's Incredible	MCA	107	C	Now
The Man From U.N.C.L.E.	Turner Ent.	132	C	Now
The Prisoner	ITC	17	C	Now
Thriller	MCA	67	C	Now
Tom Jones	ABR Entertainment	24	C	Now
Trapper John	20th Century Fox	132	C	Now
Twilight Zone	Viacom	18	C	Now
Vegas	20th Century Fox	68	C	Now
Very Special Events	Bel-Air	13	C	Now
Voyage To Bottom Of Sea	20th Century Fox	110	C	Now
Waltons	Warner Bros.	221	C	Now
We Love Lucy	Viacom	13	C	Now
Wonder Woman	Warner Bros.	61	C	Now
Wonderful World Of Disney	Buena Vista	185(Est)	C	Now

Current Firstrun Half-Hour Strips

Program	Distributor	Episodes	Terms	Available
$100,000 Pyramid	20th Century Fox	200/60	C +	Now
Animal Express	20th Century Fox	130	C	Now
Beachcombers	Blair Ent.	130	C	Now

Program	Distributor	Episodes	Terms	Available
Benny Hill	Taffner	95	C	Now
Bizarre	Viacom	130	C+	Now
CNN Headline News	Turner Ent.	365	C+	Now
Crook & Chase Show	Inter/Media Mgt.	260	B(3/3+)	Now
Current Affair	20th Century Fox	260	C	Now
Dating Game	Barris Program Sales	175/85	C++	Now
Death Valley Days	Blair Ent.	130	C	Now
Divorce Court	Blair Ent.	160/100	C++	Now
Down To Earth	Lorimar-Telepictures	104	C	Now
Dr. Who	Lionheart	260	C	Now
Entertainment Tonight	Paramount	260	C+	Now
Getting In Touch	Access	195/65	B(2+/4)	Now
Hangin' In	Orbis	110	C	Now
High Rollers	Orion	195/65	C++	Now
Hollywood Squares	Orion	195/65	C++	Now
Jeopardy	King World	195/65	C++	Now
Lingo	ABR Entertainment	130	C++	Now
Littlest Hobo	Silverbach-Lazarus	130	C	Now
Lone Ranger	Colbert	182	C	Now
Love Connection	Lorimar-Telepictures	170/90	C+	Now
Matchmaker	Orbis	130	B(3/3+)	Now
Morning Stretch	P.S.S.	130	B(3/3)	Now
Newlywed Game	Barris Program Sales	175/85	C++	Now
People's Court	Lorimar-Telepictures	195	C++	Now
PM Magazine	Group W	195/65	C+	Now
Sally Jessy Raphael	Multimedia	235/35	C+	Now
Sgt. Preston Of The Yukon	Colbert	78	C	Now
Sha Na Na	Tele Ventures	74	C	Now
Six Guns And Saddles	Fries Ent.	26	C	Now
Slim Cooking	Syndicast	195/65	B(2+/4)	Now
Split Second	Viacom	130/65	C	Now
Superior Court	Lorimar-Telepictures	170/90	C+	Now
Tales From The Darkside	Lexington	92	C++	Now
Tales Of The Unexpected	Orbis	90	B(2+/4)	Now
The Judge	Genesis/Colbert	160/100	C++	Now
Truth Or Consequences	Lorimar-Telepictures	170/90	C++	Now
U.S.A. Tonight	INN	365	B)3/3)	Now
Wheel Of Fortune	King World	195	C++	Now
Win, Lose Or Draw	Buena Vista	185/75	C++	Now

Current Firstrun Hour Strips

Program	Distributor	Episodes	Terms	Available
Donahue	Multimedia	240/20	C++++	Now
Fame	MGM/UA	136	C	Now
Geraldo	Paramount/Tribune Ent.	240/20	C++++	Now
Hour Magazine	Group W	235/25	C++	Now
Oprah Winfrey Show	King World	240/20	C++++	Now
Wil Shriner Show	Group W	240/20	C++	Now

Current Firstrun Weekly Half-Hours

Program	Distributor	Episodes	Terms	Available
'Allo, 'Allo	Lionheart	17/9	C	Now
9 To 5	20th Century Fox	26	C	Now
9 To 5	20th Century Fox	26	C	Now
All American High School Report	Western World	42/10	B(3/3+)	Now
America's Top Ten	All American	48/4	B(2+/3+)	Now
American Ski Week	I.P.I. Sports	13	B(3/3)	Now
At The Movies	Tele-Trib	46/6	B(2+/4)	Now
Bustin' Loose	MCA	26	B(3/4)	Now
Charles In Charge	MCA	26	B(3/4)	Now
Check It Out	Taffner	22/22/8	C++	Now
Christian Science Monitor Report	Monitor TV Intl.	48	B(3/3)	Now
Cinemattractions	Access Entertainment	26	B(1+/5)	Now
D.C. Follies	Syndicast	36/16	B(3/4)	Now
Directions	SFM	26	C+	Now
Dom DeLuise Show	Multimedia	24	C++	Now
Ebony/Jet Showcase	Carl Meyers	26	B(3/3)	Now
Essence	Essence Com.	26	B(3/3)	Now
Exciting World/Speed & Beauty	Access Synd.	13	B(2+/4)	Now
Fan Club	Blair Ent.	26	B(3/3+)	Now
Fight Back W/David Horowitz	King Features	26	C++	Now
Force III (3 Vets Right Wrongs)	Orbis	24	B(3/3+)	Now
George And Mildred	Taffner	38	C	Now
George Schlatter's Comedy Club	King World	26	B(3/3+)	Now
Gidget	Lexington	44	B(3/3+)	Now
Headlines On Trial	Orbis	30/22	B(3/3+)	Now
Heros	Access Ent.	26	B(2+/4)	Now
Hollywood Closeup	Access Synd.	39/13	B(2+/4)	Now
It's A Living	Lorimar-Telepictures	25	B(3/4)	Now
Jeopardy	King World	52	C	Now
Keep It In The Family	Taffner	31	C	Now
Kids Are People Too	J.M. Entertainment	26	B(3/3+)	Now
Mama's Family	Lorimar-Telepictures	44	B(3/4)	Now
Man About The House	Taffner	39	C	Now
Marblehead Manor	Paramount	24	C+++	Now
Monkees (New)	Colex	22	B(3/3+)	Now
Motorweek Illustrated	Orbis	52	B(2+/4)	Now
Music City, U.S.A.	Multimedia	26	B(2+/3+)	Now
Music Machine	Lexington	26	B(3/3+)	Now
New Wilderness	Access Synd.	18/34	B(2+/3+)	Now
Out Of This World	MCA	24	C+++	Now

Program	Distributor	Episodes	Terms	Available
Punky Brewster	Columbia	22	B(3/4)Est.	Now
Puttin' On The Hits	MCA	26	B(2+/4)	Now
Robin's Nest	Taffner	48	C	Now
Runaway W/Rich & Famous	Tele-Trib	15	B(3+/3+)	Now
Sea Hunt	MGM/UA	22	C+++	Now
She's The Sheriff	Lorimar-Telepictures	22	C+++	Now
Siskel & Ebert & Movies	Buena Vista	46/6	B(2+/3+)	Now
Small Wonder	20th Century Fox	24	C++	Now
Spect. Wrld. Of Guinness Records	Peregrine	26	B(2+/4)	Now
Sports — Pros & Cons	SFM	16/6	B(2+/4)	Now
Strictly Business	Lexington	52	B(2+/3+)	Now
Superchargers	Media-Cast	13	B(2+/3+)	Now
Tales From The Darkside	Lexington	22	B(3/3+)	Now
That's My Mama	Coca Cola Tele	22	C+++	Now
The Making Of ...	Muller Media	26	C	Now
This Week In Country Music	Jim Owens	52	B(2+/3+)	Now
This Week In Motor Sports	Spec. Events TV Net.	52	B(2+/3+)	Now
Throb	Worldvision	48	B(3/3+)	Now
Wacky World Of Sports	Orbis	12	B(3/3+)	Now
War Chronicles	Orbis	13	C	Now
We Got It Made	MGM/UA	24	C+++	Now
Webster	Paramount	26	C	Now
What A Country	Viacom	26	B(3/4)	Now
What's Happenin' Now	Colex	22	B(3/3+)	Now
Wheel Of Fortune	King World	52	C	Now
Wild Side	Lionheart	52	C	Now
You Can't Take It With You	Lexington	26	C+++	Now

Current Firstrun Weekly Hours

Program	Distributor	Episodes	Terms	Available
American Bandstand	Lexington	46/6	B(5/7)	Now
Beyond 2,000	All American	36/16	B(5/7)	Now
Blake's 7	Lionheart	52	C	Now
Classic Country	Genesis	91	C	Now
Crime, Inc.	Taffner	7	C	Now
Destination America	Taffner	9	C	Now
Entertainment This Week	Paramount	52	B(6/6)	Now
Extra, Extra	Fox/Lorber	26	C	Now
Friday The 13th	Paramount	26	B(6/6)	Now
G.L.O.W.	MG/Perrin	26	C	Now
Great Detectives	Lionheart	52	C	Now
Great Performers	Fox/Lorber	26	C	Now
Hee-Haw	Gaylord	26	B(5/5)	Now
Hurray For Hollywood	Taffner	13	C	Now
Hot Tracks	M.K. Thomas	52	B(4+/7+)	Now
Lifestyles Of The Rich And Famous	Tele-Trib	26	B(6/6)	Now
Nat'l Geographic Explorer Magazine	Turner Ent.	12	B(5/5)	Now
National Geographic Specials	Genesis	24/12	B(6/6)	Now
NCTV	Orbis	52	B(9/10+)	Now
Paper Chase	20th Century Fox	58	C	Now
Robin Hood	Samuel Goldwyn	26	C	Now
Roller Derby	Four Star	27	C	Now
Roller Derby (Original)	ABR Entertainment	56	C	Now
Soldiers	RKO	13	C	Now
Solid Gold In Concert	Paramount	45/7	B(6/6)	Now
Soul Train	Tele-Trib	36/17	B(5+/6+)	Now
Space 1999	I.T.C.	40	C	Now
Star Search	Tele-Trib	26	B(5/5)	Now
Star Trek	Paramount	26	B(7/5)	Now
Super Sports America	Gaylord Syndicom	26(90 Min)	C	Now
U.F.O.	I.T.C.	23	C	Now
Women Of The World	King World	7	B(5/7)	Now
World At War	Taffner	36	C	Now

Current Firstrun Animated Half-Hour Strips

Program	Distributor	Episodes	Terms	Available
Adv. Of The Galaxy Rangers	I.T.F./Gaylord	65/40	C+	Now
Beverly Hills Teens	Access Synd.	65	B(2/4)	Now
Bionic 6	MCA	22	B(2+/3+)	Now
Bionic 6	MCA	30	B(?)	Now
Bravestarr	Group W	65	B(2/4)	Now
Bullwinkle	DFS	98	B(2/4)	Now
Capt. Harlock	Harmony Gold	65	B(2/4)	Now
Centurians	Worldvision	65	B(2/4)	Now
Comic Strip	Lorimar-Telepictures	65	B(2+/4+)	Now
Danger Mouse	Taffner	50	B(2/4)	Now
Danger Mouse	Taffner	50	C	Now
Defenders Of The Earth	Orbis	65	B(2/4)	Now
Dennis The Menace	DFS	65	B(2/4)	Now
Devlin	DFS	16	B(2/4)	Now
Duck Tales	Buena Vista	65	B(2+/4)	Now
Dudley Do Right	DFS	38	B(2/4)	Now
Dynamen	Fox/Lorber	26	B(2+/4)	Now
Dynasaucers	Coca Cola Tv	65	B(2+/3+)	Now
Fat Albert	Group W	65	C++	Now
Felix The Cat	Screen Gems	65	C	Now
Flintstones	DFS	166/94	B(2/4)	Now
Funtastic Wrld./Han.-Barbera	Worldvision	17	B(6/12)	Now
G.I. Joe	Claster	65	B(2/4)	Now
Ghost Busters	Group W	65	B(2+/3+)	Now
Gobots	Tele-Trib	65	B(2/4)	Now
Gumby	Ziv Intl.	130	C	Now

Program	Distributor	Episodes	Terms	Available
He Man/Masters Of The Universe	Group W	65	C++	Now
Heathcliff	Lexington	86	C++	Now
Inch High Private Eye	DFS	13	B(2/4)	Now
Inspector Gadget	Lexington	86	C	Now
Jayce & The Wheeled Warriors	SFM	65	B(2/4)	Now
Jem	Claster	75	B(2/4)	Now
Jetsons	Worldvision	75	B(2/4)	Now
King Leonard	DFS	39	B(2/4)	Now
M.A.S.K.	Lexington	75	C	Now
Macron I	Orbis	65	C	Now
My Little Pony And Friends	Claster	65	B(2/4)	Now
Plasticman	Arlington	130	C	Now
Rambo	Worldvision	65	B(2/4)	Now
Real Ghostbusters	Columbia	65	B(2+/3+)	Now
Robotech	Harmony Gold	85	C	Now
Robotech II	Harmony Gold	65	C	Now
Rocky & Friends	DFS	78	B(2/4)	Now
Roman Holiday	DFS	13	B(2/4)	Now
Saber Rider/Star Sheriff	World Events	65	B(2/4)	Now
Scooby Doo	DFS	110/110/40	B(2/4)	Now
She-Ra	Group W	93	C	Now
Silverhawks	Lorimar Telepictures	65	9(2+/4+)	Now
Smurfs	Tele-trib	130	B(2/4)	Now
Space Kidettes	DFS	20	B(2/4)	Now
Speed Racer	Screen Gems	82	C	Now
Spiral Zone	Orbis	65	B(2/4)	Now
Sports Billy	Enter, Media	26	C	Now
Super Sunday	Claster	14	B(2/4)	Now
Superfriends	Lexington	110/110/40	C	Now
Teddy Ruxpin	Lexington	65	B(2+/3+)	Now
Tennessee Tuxedo	DFS	140	B(2/4)	Now
Thunderbirds	ITC	24	C	Now
Thundercats	Lorimar- Telepictures	65	B(2+/3+)	Now
Thundercats II	Lorimar-Telepictures	65	B(2+/3+)	Now
Thundersub	Lionheart	27	C	Now
Transformers	Claster	65	C++	Now
Tranzor	T.E.N.	65	B(2/4)	Now
Uncle Waldo	DFS	52	B(2/4)	Now
Valley Of The Dinosaurs	DFS	16	B(2/4)	Now
Visionaries	Claster	13	B(2/4)	Now
Voltron	World Events	125	C++	Now
Wheelie & The Chopper Bunch	DFS	13	B(2/4)	Now
Young Samson	DFS	20	B(2/4)	Now

Inserts

Program	Distributor	Episodes	Terms	Available
20th Century Woman	SFM/20th Century Fox	65	B(+)	Now
21 Days Of America	Sherry Grant	21	C	Now
Celebrity Pursuit	P.S.S.	130	C	Now
CNN News	Turner Ent.	365	C+	Now
Entertainment Report	Group W	260	C	Now
Franklin Report (Ben Franklin)	Orbis	52	C	Now
GVC Auto Tips	SPR News Service	15	C	Now
GVC Health Tips	SPR News Service	15	C	Now
GVC Tax Tips	SPR News Service	15	C	Now
Holiday Moments	P.S.S.	60	C	Now
Local Program Network	All American	52	C	Now
Miss Manners	Claster	100	C	Now
Mr. Food	King World	260	C	Now
N.I.W.S.	Lorimar/Telepictures	52	C	Now
News Travel Network (NTN)	N.T.N.	260	C	Now
Newsfeed	Group W	130	C	Now
Olympic Viewers Guide	Spr News Service	95	C	Now
Psychology Behind The News	U.S.T.V.	104	C	Oct. 87
Psychology Reports	Eagle Media	52	C	Now
Sylvia Porter's Money Tips	MG/Perrin	156	C	Now
Tax Tips	P.S.S.	65	C	Now
This Day In Hollywood	J.M. Ent.	366	B(+)	Now
Trivia Break	King World	130	C	Now
TV Facts	Scott Entertainment	50	C	Now
We The People	Syndicast	100	C	Now
Whats Cooking With Burt Wolf	Carousel	260	C	Now

Miniseries

Title	Distributor	Terms	Available
A Married Man	Viacom	C	Now
Alice To Nowhere	Paramount	B(6/6)	Apr. 88
All The Rivers Run	Orbis	B(10+/11+)	?
Bare Essence	Warner Bros.	C	Now
Best Sellers I & II	M.C.A.	Cash	Now
Blood & Honor	Taffner	C	Now
Centennial	Turner Ent.	C	Now
Count Of Monte Cristo	Harmony Gold	C	Now
Edge Of Darkness	Lionheart	C	Now
For The Term Of His Natural Life	Silverbach-Lazarus	C++/HR.	Apr. 88
Hemingway	Curran/Victor	C	Now
Hold The Dream	Tele-Trib	B(10+/11+)	Now
Mussolini & I	Orbis	C	Now
Return To Eden	Worldvision	C	Now
Sandokan	Harmony Gold	C	Now
Sara Dane	20th Century Fox	C	Now
Scruples	Warner Bros.	C++Per Hr.	Now
Shaka Zulu	Harmony Gold	C	Now
Speerfield's Daughter	Orbis	C	Now
Strong Medicine	Tele-Trib	C	Now
Thorn Birds	Warner Bros.	C	Now
V	Warner Bros.	C	Now
William The Conqueror	Harmony Gold	C	Now
Winds Of War	Paramount	C	Feb. 89

Current Live Action Childrens

Program	Distributor	Episodes	Terms	Available
Capt. Power & Soldiers Of The Future	Mattel	26	B(2+/4)	Now
Capt. Power & Soldiers Of The Future	Mattel	39	B(2+/4)	Sept. 88
Capt. Power & Soldiers Of The Future	Mattel	65	B(2+/4)	Sept. 89
Cisco Kid	Blair Ent.	156	C	Now
Double Dare	Viacom	130	B(2+/4)	Jan. 88
Flip	Hal Roach	160/100	B(2+/4+)	Sept. 88
Fun House	Lorimar Telepictures	170/90	B(2+/4)	Sept. 88
Kideo TV	Lexington	49	B(2/4)EA	Now
Kids Court	Lorimar Telepictures	130(?)	B(?)	Sept. 88
Kids Songs	Orbis	26	B(2+/3+)	Now
Littlest Hobo	Lorimar Telepictures	96	C	Now
Monster Band Takes A Stand	J.M. Ent.	26	B(2/3)	Now
Muppets	ITC	120	C	Now
Superman	Warner Bros.	104	C	Now
Trick Or Treat	Colbert	130(?)	B(?)	Sept. 88
Wombles	Mizlou	13	B(2+/3+)	Now
Young Universe	Behrens	26	C+	Now

Glossary

acquisitive promotion strategy: the portion of a promotional campaign geared toward introducing a new program or image.

ADI Market Ranking: a geographical design that identifies specific radio and television markets by noting each Area of Dominant Influence. ADI is considered to be the standard market definition for television and radio, and market size is determined and ranked according to its calculations.

Adult Contemporary (AC): a rock music format that emphasizes some Top Forty hits as well as golden oldies of the sixties and seventies. The target audience for AC is usually young professionals who fit into the 21-40 year old age group.

affiliate: a station that has agreed to associate itself with a network.

Agriculture and Farm Radio: a programming format consisting mainly of agricultural news and information such as long-range weather predictions, new techniques in farming, current market prices, and consumer demand for specific products. Although many farm programs are local in origin, several syndicated shows are popular because they provide regional or national information and attract national advertisers.

Album-Oriented Rock (AOR): an offshoot of Progressive Rock that features songs not usually found on the Top Forty charts. AOR music also emphasizes artists on the "cutting edge" of recognition as well as disc jockeys with cult music tastes, "in" language, etc.

All-Channel Receivers Act: a 1962 FCC regulation that required all television receivers manufactured after 1964 to have both UHF and VHF capabilities.

All-News Radio: a programming format that specializes in news and information. It is generally found in large and medium-sized markets and targets its shows to older (50 and over), professional, financially comfortable males.

Alternative: any radio or television programming designed to appeal to a small, highly defined audience that is not likely to be reached by typical mass appeal shows.

AOR: (see **Album-Oriented Rock**)

ARB: (see **Arbitron**)

Arbitron: a rating service for both radio and television which uses diaries as its primary method of research. Arbitron also provides overnight ratings in large cities.

audience flow: the movement of audience demographic shares (either positive or negative) throughout a certain programming daypart.

audience promotion: the portion of an image/programmatic campaign directed toward the perceived general public.

audimeter: a small black box attached to a television set that records the dates and times the receiver is turned on, as well as the selected station and program to which it is tuned.

authoritarian policy: a governmental philosophy that views media as an informational, educational, and political arm of the state. Under this system, all stations and networks are public, with few choices left to individual programmers.

barter syndication: selling syndicated shows for cash + local advertising time allotments (as opposed to cash only sales).

Beautiful Music: a programming format usually found on the FM dial, it consists mainly of easy-listening vocals or instrumental music. A staff announcer usually introduces several songs at once, so that the music has only a few commercial interruptions. Beautiful Music stations provide headline news, but their primary function is to present background music. Most of these stations are either semi- or fully automated.

benevolent policy: a governmental philosophy that views media as a vehicle for providing the public with programming that is "good" for them; not necessarily what they would like to see or hear.

Big Band Music: (see **Jazz**) a popular derivation of Jazz music which focuses on the 1930's and 1940's big band era.

Black Radio: a programming format geared specifically, but not limited to, the needs and desires of the black population within a community. Music in this format highlights Rhythm and Blues songs as well as Gospel, Disco, and Jazz; and there is a heavy emphasis on disc jockey personalities. Syndicated news and information comes mainly from the National Black Network.

blockbuster: the most expensive power programming available. The intent behind blockbuster shows is to overwhelm a network's competition during the ratings sweep weeks.

block programming: a programming strategy that airs specific shows (or types of shows) during specific time blocks. Thus, a viewer or listener must wait for a specific program or programmatic genre rather than seeing/hearing the same program type at any time of day. Today, most broadcast television is block-programmed; most radio stations and cable TV networks, on the other hand, are **format**-programmed.

CATV: Community Antenna Television (cable TV).

Classical Music: a programming format usually found on noncommercial FM radio. Classical stations are aimed toward highly educated, financially comfortable audiences. They have relatively few commercial breaks, employ staff announcers who are extremely knowledgeable about their music and composers, and provide a moderate amount of news and information to their listeners. Derivations of this format include Concert, Fine Music, Semi-Classical, and Serious Music.

college radio: educational AM and FM stations which provide a noncommercial "voice" for the community as well as training laboratories for future broadcasters.

community radio: generally low-powered facilities providing specific services that otherwise would not be available to the community.

competitive policy: a governmental philosophy that advocates minimal federal/state involvement in radio and television operations. Under this system, private ownership with commercial advertising exists, thus appealing to mass audience programming.

competitive promotion strategy: the portion of a campaign geared toward comparing a program/series to its direct competition.

co-op: (see **shared production**)

counterprogramming: the act of scheduling competitive programs that appeal to large audience segments not otherwise being served.

Country and Western Music: a programming format which appeals to a 25-54 year-old target audience. It usually features one of three types of country music ("soft" country, "hard" or traditional country, or the "Nashville sound"), and employs personality-oriented disc jockeys. Most Country and Western stations are also very community-minded, providing in-depth news, information and local public service programming. Derivations of this format include Bluegrass, Countrypolitan, and Urban Country.

CPM: the cost of reaching 1,000 persons.

daypart: a specific time block during the day that airs similar programming; e.g., early morning, late afternoon, prime-time, etc.

daypart clock: a pie-chart type figure which illustrates the various types of programming included within a typical hour of a certain time block. Certain formats have specific names for daypart clocks, e.g., in Top Forty music, they are referred to as a **hot clock**.

daytimer: a radio station that broadcasts from dawn to dusk.

DBS: Direct Broadcast Satellite.

demographics: statistical data (including gender, age, educational level, and economic status) used when deciding which commercials are most likely to reach certain people at certain times. To determine audience demographics, programmers and advertisers usually employ a ratings service such as Nielsen or Arbitron.

drive-time: morning or afternoon commuting hours.

experimental research: data-gathering by special interest groups to determine the effects of media on social behavior.

Fairness Doctrine: the portion of the Communications Act that requires stations to seek representation for all sides to a controversial issue. Since 1987, the Fairness Doctrine no longer has been considered a programming requirement. However, the decision to eliminate it is currently being re-evaluated.

first-run syndication: programs (or series) made specifically for distribution in individual markets, and have not aired previously on any network.

focus group: a homogenous group of people, brought together by researchers who want to know more about their special tastes and preferences.

format: the overall "sound" or "type" of station programming. That is, a viewer/listener can tune in at any time of day and find very similar programming. Today, most radio stations and cable TV networks are formatted; most broadcast television is **block**-programmed.

franchising: selling a special program concept (like "Romper Room"), where the individual station provides its own talent and production; but basic thematic materials are furnished by the distributor.

front-loading: scheduling the most expensive, most profitable specials or series episodes toward the beginning of a sweep month.

General Store: a type of block programming that originated in the early days of radio. "General Store" formats employ news, information, and public affairs programming as well as dramatic productions, comedy segments, talk shows, and MOR music.

Golden Oldies Music: a programming format that uses much of the same music found on **MOR** stations but limits its playlist to songs that are at least fifteen years old.

group ownership: an individual, family, or corporation that owns more than one radio, television or cable station.

HDTV: High Definition Television. A television system that uses 1050 lines of resolution at its point of origin rather than the U.S. standard of 525 lines.

hot clock: see **daypart clock**.

HUR: Households Using Radio.

HUT: Households Using Television.

independent (ownership): the owner of only one radio/television station.

independent (non-affiliated): any television station which does not have an affiliate contract with the ABC, NBC or CBS networks.

Jazz Radio: a programming format usually found on FM radio. In its purest form, jazz is very free-flowing, intellectual, and noncommercial; however, most jazz stations have commercialized their format a bit, featuring more mainstream artists like Chuck Mangione, George Benson, and B. B. King in order to attract a highly educated, professional adult audience.

large market: those areas that are ADI Market-ranked #1 - 10.

license fee: money paid by a station/network to a production company for the right to air a specific program or series. License fees are similar to rental fees--the production company or syndicator usually retains actual ownership of the program/series, and leases it only for limited use.

long-form: the strategy of extending the length of a popular program or providing an added episode to a series with the intent of raising overall ratings.

medium-sized market: those areas that are ADI Market-ranked #11 - 35.

mini-series: a television or radio series that runs for a limited time, usually two to five days.

MOR (Middle of the Road) Music: a programming format that spans the largest and most economically desirable audience segment in radio. As its name implies, MOR music is contemporary, but not extreme; and the disc jockeys are usually hired because their personality fits the pace of the station. MOR programmers also tend to provide substantial news, information and talk shows, and are often known as "good citizens" in their communities. Their basic appeal is to a 25-55 year old age group; however, most often, the older segment of this population is emphasized. Derivations of the MOR format include Easy Listening, Standards, and Adult Music.

narrowcasting: a programming strategy, emphasizing shows that appeal to small, very specialized audiences.

National Public Radio: the noncommercial, public network supported by the Corporation for Public Broadcasting.

network: a national "chain" of stations (linked together by cable or microwave) that air the same programming during their broadcast day.

Nielsen (A.C.): a rating service for television only. Nielsen uses an **audimeter** as well as diaries for its data-gathering, and provides overnight ratings in large cities.

noncommercial: any form of broadcasting that is provided by nonprofit organizations.

nonprime-time: any daypart other than 8:00-11:00 PM (EST) Mondays through Saturdays or 7:00-11:00 PM Sundays.

NPR: National Public Radio.

o & o: a station which is owned and operated by a network.

off-network syndication: reruns of programs (or series) that were first aired on a network.

playlist: the list of songs deemed acceptable and most appropriate to play on a particular radio station. Playlists usually are determined by the program director and closely fit the format, style and philosophy of the general management; they cannot be altered drastically by a disc jockey.

power programming: competition between two or more expensive, popular shows that ultimately will split a very large potential audience.

press kit: a collection of press releases, merchandise, photographs, bio sheets, etc. used to describe a specific program or campaign.

primary research: data-gathering through surveys, focus groups, and/or experiments.

prime-time: 8:00-11:00 PM (EST) Mondays through Saturdays; 7:00-11:00 PM Sundays.

Progressive Music: a programming format geared primarily toward college students and young adults. Progressive stations usually play music not found on current **Top Forty** playlists; instead, they feature songs that are less popular and more aesthetic. The disc jockeys also tend to be very articulate about the artists they showcase and seem less commercialized and more mellow in their presentational style. Progressive stations provide news and information but are not often known as significant "voices" in their communities. Derivations of this format include Underground, Album-Oriented Rock, Alternative, Free Form, and Progressive Rock.

public radio: noncommercial stations, some of which are affiliated with the National Public Radio network.

public relations: the portion of an image/programmatic campaign directed toward newspaper, magazine, radio, and television critics.

rating: the percentage of people watching or listening to a program as compared with all the sets (whether turned on or off) in all the households surveyed.

ratings sweep periods: the months of February, May, July, and November, during which advertising rates are determined for future shows.

Religious Music: a specialty radio format which usually provides full-service programming (music, talk, news, and information) within a certain religious context. These radio stations may adapt themselves to **Talk, Top Forty, MOR**, or **Country Western** formats, depending on the target audience they wish to reach.

religious radio: low-powered community stations with very specific Christian formats.

retentive strategy: the portion of a promotional campaign geared to acquiring audience loyalty to a station or network rather than loyalty to a specific show.

Rock: a major programming format begun in the early fifties. It can be subdivided into many categories, including **Adult Contemporary** (Top Forty hits and golden oldies that appeal to 21-40 year olds), **Soft Contemporary** (easy listening current hits and golden oldies which appeal to 21-40 year olds) and **Urban Contemporary** (Black Music that draws many white listeners in the 12-34 age group).

Rule of Seven: a previous FCC ownership regulation that restricted inidividuals and corporations from owning more than seven AM stations, seven FM stations and seven TV stations. The Rule of Seven recently has been expanded; it is now referred to as the Rule of Twelve, and contains specific stipulations about television ownership.

sales promotion: promotional material (such as brochures, flyers, fact sheets, video presentations, station tours, etc.) produced to aid the sales staff when they try to interest potential advertisers to a specific show or show package.

secondary affiliate contract: an agreement between a network and an independent station guaranteeing that the independent will receive any programming that has been rejected by the network's affiliate in that area.

secondary research: locating data that is already available in station files or the local library.

Section 315: the portion of the Communications Act which addresses equal time for all legally qualified candidates in an election.

share: the percentage of people watching or listening to a program as compared with all the sets turned on to shows at that time (Households Using Television).

shared production: a syndicated program (or series) whose primary production work is completed by a large production house and the rest of the show is furnished by the local station that has purchased the rights to it. (*Note:* Shared productions are also known as **co-ops**.)

small market: those areas that are ADI Market-ranked #36 +.

special network: a syndicator that specializes in certain types of programming such as secondary football games, movie packages, etc.

station promotion: the portion of an image/programmatic campaign directed toward potential advertisers.

stunting: the strategy of adding special celebrity guests, unusually controversial topics, or promotional "stunts" to a regular series with the intent of raising overall ratings.

superstation: a station that uses satellite capability to reach more than one market area.

survey: a data-gathering technique that presents a set of questions to a group of respondents.

syndication: a method of program distribution; it can include **first-run** shows, reruns of **off-network** programs, feature movies (both made-for-television and theatrical releases), mini-series, and **shared production** programs (like "PM Magazine").

Talk Radio: a programming format usually found on AM radio and specializing in news and information shows, sporting events, call-in programs and local public affairs shows. Audience demographics in talk radio differ with the program and time of day, but the key element in all dayparts is the announcer--a well-respected and/or controversial commentator for the subject at hand.

target audience: persons who possess the specific gender, age, educational level, and economic status that are most attractive to a certain program and sponsors.

time block: a designated period of time (usually 3-4 hours) in which similar programming is targeted for a specific audience demographic. See **daypart**.

Top Forty Music: a programming format that appeals primarily (but not only) to 12 to 18 year-olds, and features fast-paced music, headline news, contests, gimmicks, and a personality-oriented disc jockey. Because of its winning formula, Top Forty radio has been influential in the development of other formats, such as Adult Contemporary radio and Album-Oriented Rock. Derivations of this format include Contemporary Hit Radio, Rock, and Hit Parade.

UHF: Ultra High Frequency; channels 14 through 83.

VHF: Very High Frequency; channels 2 through 13.

Bibliography

"ABC Makes $30-Mil Commitment for 35 Hours of TV Specials." *Variety,* 4 February 1987, pp. 44, 150.

Alsop, Ronald. "To Plug Shows, TV Networks Take a Cue From Advertisers." *The Wall Street Journal,* 17 December 1987, p. 29.

Baker, Kathryn. "CBS Cancels Nielsen Rating Pact." *Boston Globe,* 8 July 1987, p. 40.

Barton, Jane. "Vet Albany News Chief Dumped after 25 Years with TV Station." *Variety,* 4 March 1987, p. 97.

_____. "WRGB Schenectady News Champ in N.Y.S. Sweeps; WNYT Climbs." *Variety,* 30 December 1987, pp. 27, 33.

Beerman, Frank. "Basic Cable Webs Turn Profit Corner." *Variety,* 7 October 1987, pp. 45, 88.

Belsky, Gail. "Giving the News its Personality." *Adweek,* 18 August 1987, pp. 18-19.

"Big Bang from Peoplemeters Was Little More Than Whimper." *Variety,* 30 September 1987, pp. 36, 120.

Broadcasting/Cablecasting Yearbook 1982. Washington, D.C.: Broadcasting Publications, Inc., 1982.

Broadcasting/Cablecasting Yearbook 1984. Washington, D.C.: Broadcasting Publications, Inc., 1984.

Broadcasting/Cablecasting Yearbook 1986. Washington, D.C.: Broadcasting Publications, Inc., 1986.

Broadcasting/Cablecasting Yearbook 1987. Washington, D.C.: Broadcasting Publications, Inc., 1987.

Broadcasting/Cablecasting Yearbook 1988. Washington, D.C.: Broadcasting Publications, Inc., 1988.

Brooks, Tim, and Earle Marsh. *The Complete Directory to Prime Time Network TV Shows: 1946-Present.* Rev. ed. New York: Ballantine Books, 1981.

CBS Affiliate Relations: 1987-1988 Primetime Scheduling Rationale. New York: CBS Television Network, 1987.

"CPB to Adopt Safeguard Regs Protecting All TV Program Funds." *Variety,* 23 March 1988, p. 115.

Cieply, Michael. "TV Syndication Market May Be Cooling." *The Wall Street Journal,* 29 January 1986, p. 6.

"Classic Rock Format Draws a High Rating." *Detroit Free Press,* 17 July 1987, p. 1C.

Coleman, Howard W. *Case Studies in Broadcast Management.* New York: Hastings House, 1970.

Cornet, Barry. "Now See This: There's Our Crack Reporter--with Wonder Woman and Spiderman." *TV Guide,* 16 January 1988, pp. 36-38.

"Debuting from a House, KNX Radio Oldest Operating Station in L.A." *Variety,* 30 September 1987, p. 114.

Dempsey, John. "'Cagney' on Cable Rankles Stations." *Variety,* 9 December 1987, pp. 35, 68.

_____. "Gotham TV Skeds Go Loco over Local." *Variety,* 12 August 1987, p. 61.

_____. "It's Checkmate for NBC Checkerboard." *Variety,* 23 December 1987, p. 41.

_____. "Sports Now & 100-Mil Barter Bonanza." *Variety,* 29 July 1987, pp. 93, 116.

_____. "Syndie Barter Biz is Booming, $800-Mil '87-'88 Season Seen." *Variety,* 22 July 1987, pp. 57, 69.

_____. "Syndie TV Becoming Tower of Babble." *Variety,* 26 November 1986, pp. 105, 128.

_____. "TV Affils Go Soft on Preemption: Compensation Coin Keeping Most in Line." *Variety,* 2 December 1987, pp. 1, 111.

Epstein, Aaron. "Court to Decide Who Sets Cable TV Quality." *Detroit Free Press,* 1 December 1987, p. 12A.

"Fox Syndie Plans 'Current Affair' For a Prime Access Cash Strip." *Variety,* 22 July 1987, pp. 57, 71.

"Gab Shows Save Detroit ABC Affil from NBC Victory." *Variety,* 11 March 1987, pp. 46, 88.

Gelman, Morrie. "Cable vs. Public Broadcasting." *Variety,* 26 August 1987, pp. 1, 96.

_____. "Fee-Spot Abuses Rankling TV Stations." *Variety,* 11 March 1987, pp. 45, 90.

_____. "Hollywood Producer Pubcaster Push: National Indie Service Formed." *Variety,* 6 April 1988, pp. 35, 58.

_____. "Meters & VCRs Shaping P'Time Ploys." *Variety,* 20 May 1987, pp. 49, 80.

_____. "NBC First at Bat with Peoplemeter." *Variety,* 29 July 1987, pp. 95, 118.

_____. "TV Stations Turn to Events, Stemming the Flight to Cable." *Variety,* 9 December 1987, pp. 40, 64.

_____. "Westerns in Networks' Saddle Again." *Variety,* 2 December 1987, pp. 39, 86.

Goodgame, Tom. "Public Service TV Makes Sense in Marrying Station and Market." *Variety,* 27 January 1987, pp. 146, 188.

Greenfield, Jeff. "Life Without Cable? No Way!" *TV Guide,* 29 August 1987, pp. 4-6.

Gunther, Marc. "Network Needs to Out-Fox the Competition." *Detroit Free Press,* 10 January 1988, pp. 1E, 4E.

Harris, Paul. "PBS at 20: Proud, Beggared, Searching: Time to Ponder Next 2 Decades." *Variety,* 16 September 1987, pp. 65, 98.

Hill, Doug. "The Rage of Knoxville: Where Hal Wanzer is Bigger than Dan Rather." *TV Guide,* 13 February 1988, pp. 26-30.

Howard, Herbert H., and Michael S. Kievman. *Radio and TV Programming.* Columbus, OH: Grid Publishing, Inc., 1983.

Isaacson, Paul. "Firstrun Product Stimulates Growth of Barter Syndication, Although Show Glut Threatens." *Variety,* 27 January 1987, p. 146.

"A Jazz Station Grows in Newark." *Variety,* 20 January 1988, pp. 175, 192.

Jensen, Elizabeth. "Budget Knots at Gotham Stations Have Local Stringers Dangling by a Thread." *Variety,* 13 January 1988, pp. 39, 66.

_____. "Followup to 'Mission' Survey: News Study Sez Viewers Prefer Story 'Repetition.'" *Variety,* 2 September 1987, p. 52.

_____. "Guarantees Yield Nielsen ABC-TV Pact." *Variety,* 23 September 1987, pp. 123, 154.

_____. "Latest Peoplemeter Results Shift Web Standings (Again)." *Variety,* 5 August 1987, p. 39.

Jerome, Al. "NBC Checkerboard Methodology: Build the Shows, Viewers Follow." *Variety,* 21 January 1987, p. 120.

Kane, Eileen. *Doing Your Own Research: How to Do Basic Descriptive Research in the Social Sciences and Humanities.* New York: Marian Boyars, 1985.

Kassof, Mark I. "Using Multi-Dimensional Scaling to Find Your Station's Niche." *Research and Planning: Information for Management.* A research memo prepared for the National Association of Broadcasters, October 1985.

Keith, Michael C. *Radio Programming: Consultancy and Formatics.* Stoneham, MA: Focal Press, 1987.

Kern, Arthur. "Local TV Programming: The Long-Term Advantage." *Variety,* 9 January 1985, pp. 82, 154.

Kipps, Charles. "Hi-Definition Vid Clearly on the Way." *Variety,* 16 September 1987, pp. 3, 122.

_____. "Homevideo Now after TV Oldies." *Variety,* 7 October 1987, pp. 1, 116.

_____. "National Video's Berger Tells Analysts P-P-V is Biggest Threat." *Variety,* 16 September 1987, p. 105.

Kneale, Dennis. "TV Producers Turn More Cautious as the Syndication Market Shrinks." *The Wall Street Journal,* 1 March 1988, p. 33.

Knight, Bob. "ABC Puts Faith in 'Amerika' During Feb. Ratings Sweeps." *Variety,* 4 February 1987, p. 44.

_____. "Gone Today, Here Tomorrow: Show Genres May Fade Away But Can Rise from the Grave." *Variety,* 27 January 1987, pp. 142, 164.

_____. "Holiday Specs not Surefire Anymore." *Variety,* 16 December 1987, pp. 35, 74.

_____. "Put-Up-Or-Shut-Up Time at Webs: They talk 'Quality' but Will They Support It?' *Variety,* 6 April 1988, pp. 1, 62.

_____. "Sweeps Strategy in Preparation." *Variety,* 28 October 1987, pp. 41, 70.

Kostyra, Richard J. "Barter Syndication: A Hybrid--Not Like Network or Spot." *Television/Radio Age,* 13 January 1986, pp. 180-181, 394-395.

"Line Grows Fine Between Indie, Pubcaster Stations." *Variety,* 8 October 1986, p. 118.

Lippman, John. "Loss Seen at CBS-TV in 1987 Unless Scatter and Ratings Perk; Red Ink Engulfs Two Networks." *Variety,* 27 January 1987, pp. 141, 164.

_____. "News Organizations Experiment with Entertaining Techniques to Promote Big-Gun Anchors." *Variety,* 7 January 1987, pp. 39, 124.

_____. "TV Blurb Rebound Slow-Boils Spot Pot." *Variety,* 12 August 1987, pp. 51, 86.

Matelski, Marilyn J. *The Soap Opera Evolution: America's Enduring Romance with Daytime Drama.* Jefferson, NC: McFarland and Company, 1988.

McCabe, Bruce. "Two Cable Networks Present Arts, Culture." *Boston Globe,* 17 April 1988, p. B5

Miller, Annetta, Janet Huck, and Maggie Malone. "TV's Troubled Independents." *Newsweek,* 16 February 1987, p. 50.

Murphy, Thomas S. "Net TV has Reached Maturity, so Growth's No Longer Sure Bet." *Variety,* 22 January 1988, p. 175.

NAB Guidelines for Radio: Promotion I. Washington, D.C.: National Association of Broadcasters, 1981.

NAB Guidelines for Radio: Promotion II. Washington, D.C.: National Association of Broadcasters, 1985.

"NBC-TV Cleans up in Sweeps, but Web Stunting Gains Little; Regular Series Strength the Key." *Variety,* 11 March 1987, pp. 46, 86.

"NBC Exec Believes P-Meter Research is at Times Invalid." *Variety,* 13 January 1987, pp. 1, 48.

Nilsson, Sam. "Knowing What Has Gone Before Can Help World's Public Broadcasters Prep for What's to Come." *Variety,* 7 January 1987, p. 101.

Norback, Peter G., and Craig T. Norback, eds. *TV Guide Almanac.* New York: Ballantine Books, 1980.

"PBS New Series and Specials Fall '87 Season." *Variety,* 30 September 1987, pp. 78, 80.

Pattiz, Norman. "Radio's 'Golden Age' Over; This is its 'Platinum Age' as Webs Take New Tack." *Variety,* 20 January 1988, p. 176.

"Peoplemeters: Variety's Coverage Plan." *Variety,* 16 September 1987, p. 103.

Peterson, Bettelou. "TV Tailors Offerings to Maturing Audiences." *Detroit Free Press,* 31 March 1987, p. 3B.

Powers, Robert L. "Columbus Affil Scraps Local News." *Variety,* 9 September 1987, pp. 52, 63.

Quinn. John. "Summer ARBs Push KBEQ-FM to Surprising K.C. Top Honors." *Variety,* 4 November 1987, p. 47.

"Radio's New Golden Age: Programmers Tune in to Profits." *Newsweek,* 3 August 1987, p. 41.

"A Ratings Revolution?" *Newsweek,* 14 September 1987, p. 76.

Ratliff, Rick. "Electronics Charge Ratings Game." *Detroit Free Press,* 13 September 1987, pp. 1E, 6 E.

Rhodes, Bill. "1980 Public Radio Conference--Sound Thinking: Fine Tuning the Future." *Broadcast Engineering,* May 1980, pp. 54-70.

Robins, J. Max. "The Alchemy of Network Scheduling." *Adweek,* 18 August 1987, pp. 36-37.

Robinson, Robert. "NBC Checkerboard Castles Competition in Prime Access." *Variety,* 23 September 1987, pp. 121, 154.

Rowland, Willard D., Jr. "Continuing Crisis in Public Broadcasting: A History of Disenfranchisement." *Journal of Broadcasting & Electronic Media* 30 (Summer 1986): pp. 251-274.

Rubens, William S. "Program Research at NBC, or Type I Error as a Way of Life." *Research & Planning: Information for Management.* A research memo for the National Association of Broadcasters based on a paper presented at the ARF 10th Annual Midyear Conference in Chicago, September 1984.

Rubin, R.B., A.M. Rubin, and L.J. Piele. *Communication Research: Strategies and Sources.* Belmont, CA: Wadsworth Publishing, 1986.

Saxton, Judith. *Audience Research Workbook.* Washington, D.C.: National Association of Broadcasters, 1983.

Segers, Frank. "Cubs Baseball Does Nosedive in Chi Arbitron." *Variety,* 22 July 1987, pp. 56, 70.

Sharkey, Betsy. "Revenge of the Network Affiliates." *Adweek,* 18 August 1987, pp. 2-4.

Sherman, Eric. "Who's the Best? Donahue? Oprah? Someone Else?" *TV Guide,* 26 March 1988, pp. 25-30.

Silverman, Michael. "Public TV's Increased Competition for Programs Weighed at NATPE." *Variety,* 28 January 1987, p. 43.

"Sweeps Suggest Still Some Bugs in Peoplemeter." *Variety,* 23 December 1987, pp. 39, 54.

1987 Television Employee Compensation & Fringe Benefits Report. Washington, D.C.: National Association of Broadcasters, 1987.

"TV Indies Chafe at Network Intrusion; Leery of New Bids." *Variety,* 28 January 1987, pp. 36, 58.

Traub, James. "The World According to Nielsen: Who Watches Television and Why." *Channels,* January/February 1985, pp. 26-30, 70-71.

Understanding Broadcast Ratings. New York: Broadcast Rating Council, Inc., 1978.

"USA Network's 'Miami' Deal Signals Cable's Growing Clout." *Variety,* 18 November 1987, pp. 38, 68.

Waters, Harry F., and Janet Huck. "Dawn of the 'Dramedy.'" *Newsweek,* 7 December 1987, pp. 97-99.

"The Wave Hits Los Angeles, and a Classic Drifts Away." *Newsweek,* 1 June 1987, p. 68.

Webster, James. *Audience Research.* Washington, D.C.: National Association of Broadcasters, 1983.

Weisman, John. "Public TV in Crisis, Part I." *TV Guide,* 1 August 1987, pp. 2-11.

_____. "Public TV in Crisis, Part II." *TV Guide,* 8 August 1987, pp. 26-40.

Wharton, Dennis. "Indie TV Facing Slower Growth." *Variety,* 7 January 1987, pp. 39, 124.

Wright, Charles R. *Mass Communication: A Sociological Perspective.* 2nd ed. New York: Random House, 1975.